Saskatchewan *Uncommon Views*

The University of Alberta Press

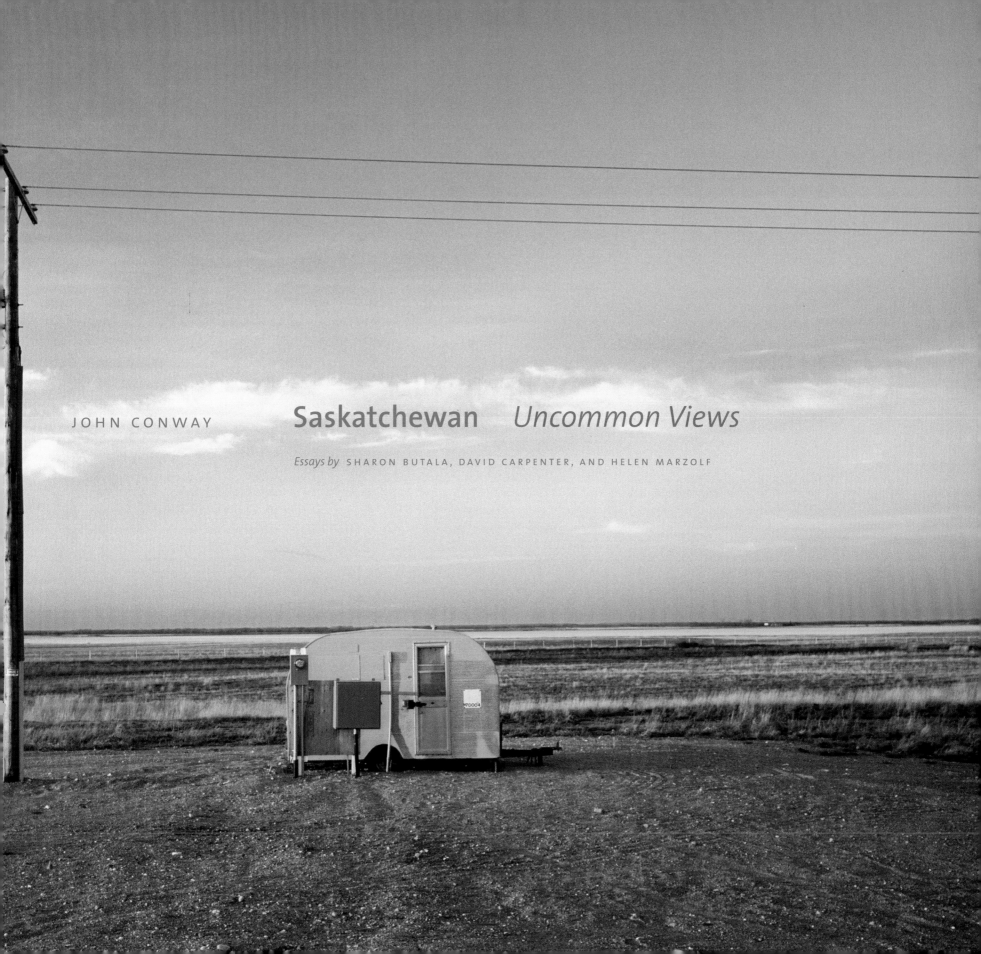

JOHN CONWAY Saskatchewan *Uncommon Views*

Essays by SHARON BUTALA, DAVID CARPENTER, AND HELEN MARZOLF

Published by

The University of Alberta Press

Ring House 2

Edmonton, Alberta, Canada T6G 2E1

John Conway photographs and notes copyright © 2005

Sharon Butala essay copyright © 2005

David Carpenter essay copyright © 2005

Helen Marzolf essay copyright © 2005

Library and Archives Canada Cataloguing in Publication Data

Conway, John, 1945–

 Saskatchewan : uncommon views / John Conway.

Includes essays by Sharon Butala, David Carpenter and Helen Marzolf.
ISBN 0–88864–454–X

 1. Saskatchewan—Pictorial works. I. Butala, Sharon, 1940– II.
Carpenter, David, 1941– III. Marzolf, Helen IV. Title. V. Title:
Uncommon views.

FC3512.C65 2005 971.24'04'0222 C2005-904563-9

Printed and bound in Canada by Friesens, Altona, Manitoba.

First edition, first printing, 2005.

All rights reserved.

The University of Alberta Press gratefully acknowledges the support
received for its publishing program from The Canada Council for the
Arts. The University of Alberta Press also gratefully acknowledges the
financial support of the Government of Canada through the Book
Publishing Industry Development Program (BPIDP) and from the
Alberta Foundation for the Arts for its publishing activities.

The University of Alberta Press gratefully acknowledges the financial
support provided for this book by the Saskatchewan Arts Board.

For Dan, Nathan, and Alix

"Hey guys, look at these pictures.
Which do you like best?"

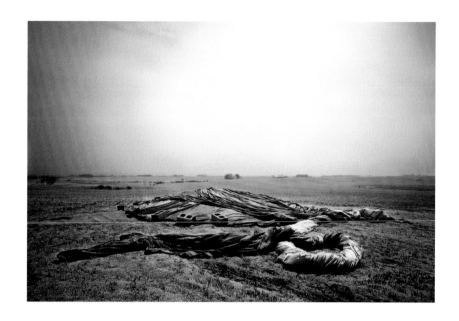

Contents

Acknowledgements

I BOUGHT MY FIRST CAMERA a couple of years after coming to live in Saskatchewan. It was the prairie—its land, sky and light—that lured me out of the city to look around and take pictures. Over the years, whenever I grew tired of driving and looking, it was the rural people I met that fortified me.

The next year, I took a "how to" course at The Photographers' Gallery in Saskatoon. Our homework after the first class was to walk around our blocks and take a roll of pictures. The next class, James Lisitza, our teacher, showed one of my slides on the big screen, for about five minutes, asking us to look and "free associate." I'd never looked at a picture, nor free associated, for five full minutes.

Since then I've looked at a lot of photographs. I owe a debt to many remarkable photographers that have shown me how they see the world. The pictures and writing of Robert Adams have sustained me over many years. Other influences on the photographs in the book have come from Roy Arden, William Eggleston, Walker

Evans, Robert Frank, Peter Goin, Len Jenshel, Sally Mann, David McMillan, Joel Meyerowitz, Richard Misrach, Stephen Shore, Joel Sternfeld, and Gary Winogrand.

The photographs for the book were taken over the past twelve years. When I thought I might have a book, I knew I needed help. John Paul Caponigro taught me as much about Photoshop as I was willing to learn; Sam Abel's love of photographic books inspired me to persevere. Both encouraged me in ways that I'm not fully aware of, as have others: Mim Adkins, Bruce Barnbaum, Keith Bell, Lynne Bell, Leah Bendavid-Val, Linda Book, Joan Borsa, Frish Brandt, Dan Fox, Alice Rose George, Donna Jones, Honor Kever, Marie Lanoo, Joyce Lopez, Peter Milroy, Thelma Pepper, Reed Thomas, and Doug Townsend.

I have "gone out photographing" with only one other person in my life, my friend Garth Abrams. When we arrived at a place, we usually walked off in different directions, each preferring our own way. Back in the city, Garth and I have talked about photographs a great deal. He has been my best critic. Other friends have been good enough to look at and talk about my photographs, especially Sue Abrams, and Len and Isobel Findlay.

I am honoured to have the writing of Sharon Butala, David Carpenter, and Helen Marzolf to accompany the pictures. Their words bring new meanings to my sense of this place and also to pictures that I thought I'd seen enough.

The University of Alberta Press has been very good to me: Michael Luski eagerly, bravely, took the book on and Alethea Adair has shepherded it with great care; Alan Brownoff's eye for design has made it look better than I could have imagined; and Cathie Crooks's enthusiasm may just be contagious enough to make the book a "seller;" and Josh Bilyk and Linda Cameron, Director, have always provided just the right kind of support necessary to make the book a reality. Linda is from Saskatchewan, of course.

Linda McMullen, my wife, has both supported and put up with me. She is also the second best critic of my work. Thanks, Linda.

JOHN CONWAY
Saskatoon, June, 2005

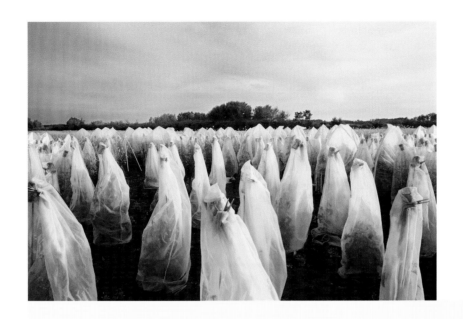

Saskatchewan *What Meets the Eye* SHARON BUTALA

Experimental canola No. 1, near Rosthern

THE AMERICAN WRITER, Wallace Stegner, ends *Wolf Willow: A History, A Story, and a Memory of the Last Plains Frontier*, his 1962 book about a Saskatchewan town he calls Whitemud, with the prediction that the town will "remain marginal or submarginal in its community and cultural life." Then he says, "Give it a thousand years"—not twenty or fifty or even one hundred, but a thousand, which is about the same as saying *never*. Whitemud is, in fact, the town nearest my home, the real name of which is Eastend, located in the extreme southwest corner of our province. Stegner and his family arrived in Whitemud/Eastend in early 1914, two months before the town was incorporated, but he might have written these same genially disparaging comments about any prairie town of the period he had come to know as intimately as he did Eastend. But, his prediction of the town's future came back to haunt him in the late eighties, when I wrote to him that the community college was sponsoring a certain program in Eastend. He replied, "A college in Eastend! Well, well!"

That Eastend was merely one participant in a college with a tiny headquarters in Swift Current whose purpose was to offer courses in whatever community requested them, I did not bother to tell him. This may have happened just before his death in 1993, and perhaps I never got the chance. It is more likely that when I read that end passage in *Wolf Willow*, I found it so embarrassingly extreme in its sentiment—or maybe I had thought he had to be kidding—that I simply paid it no attention, did not even remember it, and so my misleading remark about the college was made in innocence.

In any case, he wrote that passage from the vantage point of a prize-winning American writer, a revered university professor with a doctorate in literature, and a man who, from the time he left Eastend for Great Falls, Montana, around the spring of 1920 or '21, was never again a small-town resident. When he lived here, he was a child in a more or less ne'er do-well family, with a father (according to his son's own account) who was half-scoundrel and half-pitiable, and a mother who wanted to create Wallace as a humane, well-spoken, well-read gentleman—while raising him in a remote frontier town. Clearly, a recipe for disaster, and the pronouncement I've quoted above, as well as being a blow struck at his old enemies, reveals the result on Stegner's thinking. He did not see the humour; he did not forgive (however much he might protest that he did); he did not much respect those country and small town folk for their toughness, their courage and endurance, their wide capacity for despair and for hope, for their dry humour, and their long and wise silences. And certainly, he had no eye for the amusing quirks of such communities.

Growing up in the Western United States, he became a prominent conservationist, deploring the destruction of nature by human beings; like many conservationists, he seemed to want a pristine West, uncontaminated by people, a self-defeating stance if ever there was one. And yet, who can blame him? Coming from where he did. In every book where he hearkened back to his not-so-fictional Whitemud, and to his childhood on the northern Great Plains, he saved his love, his passion, his joy, for the land itself—for nature. He had had embedded in his consciousness at an early age, the wonder of the unbroken, grassy prairie, the vast, many-layered sky, the terrifying and wonder-inducing extremities of the seasons and the weather. As a boy, he learned intimately how the prairie worked, he took it in, although he would be a man before he would understand what had entered him so viscerally and with such power, when he was a child. As a man, he learned to deplore what was being lost even then, when he'd been free all summer long to wander the prairie along the forty-ninth parallel, an arbitrary boundary between Montana and Saskatchewan, where his parents' had a few acres of dryland farm. He was grown before he understood that the very land he so loved had belonged to the Aboriginal people before the arrival of the settlers and the deliberate and cruel removal of them by the new white powers.

He would be a man, too, before he would understand that farming such land was far more often a failure than a success and that it always, therefore, destroyed the best things about it. (That very farm has gone back to grass and is now a part of a Prairie Farm Rehabilitation Administration, PFRA, pasture.) By the time Stegner died in 1993, the industrialization of the land was already a fact, and now, more than ten years after his death and eighty-five since his residence here, we have entered the era of vast farms and monster equipment, and the resulting near-emptying of the

countryside of human beings. Recently, a politician remarked to me that the time of one-hundred- thousand acre farms, worked by enormous, robotized machines, would be here within ten years. If Wallace Stegner is looking down now at the landscape that once, both as boy and man, so enchanted him, I think he is weeping. But, perhaps also he has finally managed to reconcile what he never could in life—that if his boyhood here on the northern Great Plains was full of lessons about what never to do, what never to be, it was also full of life-altering, unforgettable gifts. Gifts that were not just the awe that comes from intimacy with nature, but also, from intimate contact with mystery.

I have often told about the time when we were moving cows from the ranch to their winter home, a forty-mile, three-day trip, when it was forty below Fahrenheit and much too cold to use horses. Instead, we drove trucks, and whenever we took a coffee break, everybody piling into the super-cab of one truck, we didn't dare to turn off the motors of any of the others for fear that in that unimaginable, bitter, windless cold, they wouldn't start again. On one occasion, as we sat sipping our steaming, rye-laced coffee from thermos cups, I happened to notice that the exhaust from one of the half-tons parked next to us, was pinging out one perfect smoke ring after another. "Look!" I said. For a long, silent moment, everyone looked. "Hmm," and "Humph," they said, and went back to drinking coffee.

It would have been the next spring that, one morning, my husband brought a large, fresh fish into my prairie kitchen. Mystified, I asked him, "Where did you get that?" He plunked it down on the counter. "Shot it," he said. I stared at him quizzically. He stared back, unmoved. "Oh," I said. After a second's thought, I informed him, "Well, I'm not cleaning it." He took the

fish out again, and when next I saw it, it was scaled, degutted, and sliced into neat white fillets, which I sautéed for our lunch.

Or, there was the time I was giving a reading at a library in a small southwest Saskatchewan town which happened to be having a mayoralty race, and because of this, instead of the usual half-dozen women, I had an audience of twenty-five, including a large number of actual men. I read a passage from one of my early novels about a ranching family in a remote location wakened in the night by the baying of the ranch dogs, the mooing of all the cattle, and in the distance, the howling of coyotes. Not only that, but the entire night sky was lit up as if it were day. The family stood outside the door of their cabin in their nightclothes, gazing in wonder at the sky and the lit-up hills, until slowly, the light died, the animals quieted, and normalcy returned. I had been told this story by the family who had experienced it, but nevertheless, I expected my audience to perhaps question my sanity. Instead, they began to tell similar stories about their own long lives on the open prairie, on ranches and farms far from cities. Everyone had a story; every story was about an event of this sort, each and every one without rational (scientific) explanation. When they were finished, we were—all of us—sobered, proud, a bit awe-struck, and secretly delighted by the mostly unsung wonders of this place in which we had made our lives.

Is there any place in the country so subject to comfortably-believed, derogatory myths about its lack of beauty, its flatness, its general hickness, and its dullness as Saskatchewan? Not in my experience, and, as someone born, raised, and educated here, I have changed from the child who believed all of this to be true—even while I lived in the midst of mystery and beauty—to an adult who sees at last, that there can be

no more desirable place in this country. And so, with the exception of the young for whom home is seldom sufficient—and a good thing, too—Saskatchewan people, as a whole, do not yearn for other places and other lives. We are instead filled with a kind of exasperated surprise that the rest of the country thinks us dull, and thoroughly hick-ish flatlanders. We bitterly dispute the claim of flatness; our province is flat only around the trans-Canada highway; we accept that we are perhaps hicks, but not only treasure our so-called hick-ness, but think it too bad that others are unable to see it for what it is—a different kind of wisdom; the idea that we, and our home, are dull, we see simply as foolishness.

John Conway's photos, startlingly original in their view of this province, have captured exactly what strangers have failed to see, and what it would not occur to us to try to explain to others, feeling either that others wouldn't understand, or, while secretly valuing this sort of thing, fearing that pointing it out would subject us to the ridicule of the uncomprehending many. Conway picks up that which exists below the level of consciousness, captures it, and puts it on display. "*Oh, yeah!*" We say, "*That's it! That's how it is!*" And it is a brilliant seeing. He sees the irony that pops up everywhere you look—for instance, the beauty of the sewage lagoon at Waskesiu (page 78); he sees the oddness of things here—experimental canola, each plant swathed in plastic to create a field of ghosts (page 29); he sees this in abandoned windmills that once drew water, in stone piles in the corners of fields all over the cropland, he sees it even in roadkill. As a photographer he has an immense, delighted sense of humour about what he sees, and out of that sense of humour we understand his clear fondness for this place.

I think we are coming of age, and cultural events such as the enormously successful television comedy, *Corner Gas*, the brainchild of Tisdale, Saskatchewan comedian, Brent Butt, and this book by John Conway of original, humorous, and beautiful photos, that capture Saskatchewan's true flavour, (instead of photos working to capture only its beauty), are examples—even pinnacles—of this new level of self-understanding. Now, at last, we can be amused by our own foibles—we even know what they are—and denial of them is no longer necessary. We have become comfortable with ourselves. As for the great Wallace Stegner, if he is weeping over the industrialization of the wild land which he loved as a boy with such passion, I think he is also giving John Conway a ghostly, affirmative pat on the back for these photographs, which are not just pure celebration, but may also be read as critical appraisal—but it is loving appraisal. And just maybe, Stegner is also beginning to accept that culture is not just Italian opera, Greek statues, and Shakespeare, but the way a land and a people work together to produce a new sensibility.

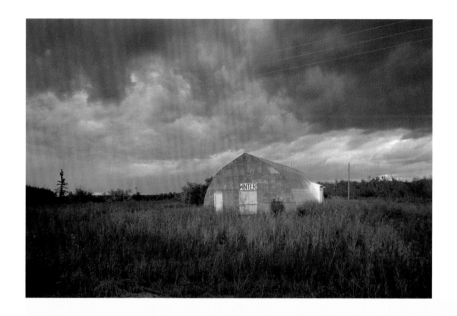

Former Hamlet of Winter, Rural Municipality of Senlac

Post-Pastoral Rural *John Conway's Dissonant Landscapes* HELEN MARZOLF

ONE OF MY FAVOURITE LANDSCAPES appears in a droll scene from the Coen Brothers' film *Fargo*. In it, the feckless Carl Showalter (Steve Buscemi) stops to bury a briefcase full of unmarked bills in a snow-filled highway right-of-way, shovelling frantically with a windshield scraper. Carl looks up from his digging to get his bearings, thinking ahead to how he would later find the ransom. The camera scans his landscape—the highway and nearby barbed-wire fence converge at an infinite horizon. Looking left then looking right, no tree, no building, no marker of any sort. He's alone on a limitless stage of blue sky and white land where all human deed and misdeed is readily witnessed. Carl's next move is predictably desperate—he marks the spot with the windshield scraper, then speeds off into the remaining debacles of the film. The futility of his gesture is hilarious, grim, and uncannily revealing. *Fargo*'s insistently utilitarian landscape is a backdrop to the Coen Brothers' tale of human foible and to historical refrains of the west: migration, desperation, making

a quick buck, and looking back and forth at a far horizon trying to locate oneself.

John Conway's photography of rural Saskatchewan travels the same industrial spaces as the Coen Brothers' North Dakota, though to less grisly ends. Thematically, Conway's disjunctive landscapes probe a prairie ethos at a moment of transition. The rural culture has been all but subsumed by the urban; the industrial base of rural Saskatchewan is dormant; and the narrative of settlement no longer propels the business plan nor ignites the imagination. As a timely photo essay, *Saskatchewan: Uncommon Views* could have been made only by someone obsessed with the paradoxes of contemporary Saskatchewan as it searches for sustaining mythologies and economies amidst swirling psychologies, histories, and aspirations.

Conway's project, a vigorous reconsideration of a particular landscape genre, is persistently oxymoronic: industrialized pastoral, an invisible familiar, deracinated home place, historical present, a mythistory turned inside out.[1] His work combines the tradition of the pastoral landscape, late modern American photography, and an affectionate engagement with place.

Roughly the size and configuration of easel painting, Conway's giclée (archival inkjet) prints frame identifiable rural topographies creased by emphatic horizon lines; all revel in the extraordinary beauty of the plains. Occasionally he digitally heightens colour, crops, extends and minutely adjusts imagery, just as a landscape painter might, but stops short of compromising the sense of documentary photography. *Snow Geese, Duck Lake* (page 6) captures the mesmerizing dance of the fall migration. *Rural Municipality of White Valley, No. 1* (page 5) synthesizes the phosphorescent light of a stubble field with that of first snow. *Rural Municipality of Viscount* (page 54) mirrors radiant sky

on eerie landlocked ice flows. These three, like others, are titled with fanciful municipality names (who knows how long these names will remain in use), and are wholly reliant on the breathtaking accidents of light, colour, and natural phenomena. But these are exceptions. Conway's landscapes are typically industrial, saturated by human presence despite the complete absence of figures.

In his way, Conway is a raconteur. Rather than photographing people, he frames visual anecdotes, which are variously amusing, eccentric and sometimes disquieting. In *Rural Municipality of Lost River* (page 13), a bicycle frame is mounted on a fence post. As an example of the ingenuous art encountered frequently in rural Saskatchewan, this could be seen as uncontrolled packrat-ism—finding a new use for anything and everything—or a monument to an irrepressible urge to tinker. The bicycle assemblage occupies the centre of the image, a position normally occupied by a figure. This playful cipher is poised atop yellowed grasses and a loosely strung fence, surrounded by receding lines of cultivation and the delicate pastels of dusk in a late September sky. *Rural Municipality of Lost River* is absurd and lyrical, and the tension between these dissonant qualities is not readily resolved. Instead, it lets us enter a space of inquiry. Caroline Heath identified a similar strategy in Robert Krotesch's poetry:

His use of silence/space within the poem recreates a key characteristic of Prairie speech. The loquacious storyteller is less typical here (at least among non-Natives) than the person who speaks quickly, in bits and phrases, often omitting the main point or not saying what he really thinks.[2]

Conway has a flair for leaving things unsaid. *Grain tarp, Rural Municipality of Hoodoo* (page 30) would be an uncomplicated pastoral landscape if it were not dominated by a wind-whipped tarp, twisted into gigantic viscera, sprawling incongruently against a hazy harvest backdrop. Conway jars expectation and prods speculation about what, exactly, is going on in rural Saskatchewan. At the centre of *Shirl's Upholstery, Highway 2, near Domremy* (page 110) a hand-painted sign, "Shirl's Upholstery 423-6285," stakes a showy claim within a moody, overcast sky. Shirl's enterprise may look vulnerable, hardly the desired result of farm diversification policies, but she's been in business for over two decades. Shirl's plastic sign, a foil to the natural drama surrounding it, signals sustainability rather than conquest and mastery. Conway pries open the closed shop of the prairie landscape genre, renovating tropes to begin imagining other kinds of land relationships.

Though Conway's photographs are unmistakeably contemporary, he is nevertheless influenced by historical landscapes. He pays homage to Humphrey Lloyd Hime's famous collodion print *The Prairie looking west* (page 133) by emulating it in *Salt flat, on Pamela Wallin walk, Wadena Wildlife Wetlands* (page 105). Conway's insistently straight horizon lines are another genuflection to Himes's strange, staged image. Other precedents of how landscape is depicted, such as immigration posters, circulate in Conway's photographs. Clifford Sifton's tenure as Minister of the Interior, from 1896 to 1905 sparked a marketing campaign that drew two million immigrants to western Canada. Brochures and posters lured immigrants with idealized visions of prosperous and orderly rural landscapes, an attractive alternative to the social and economic discontent of late nineteenth and early twentieth century conditions

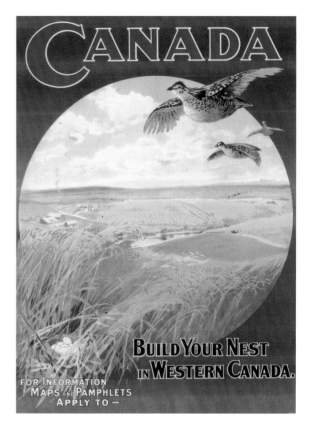

"*Build Your Nest in Western Canada,*" National Archives of Canada, C126302

in the British Isles, the US, and Europe. Such images are still powerful signifiers in contemporary advertising, marketing and art.[3] Compare Conway's cogently framed *Regina* (page 94) with the immigration poster *Build Your Nest in Western Canada*. In Conway's photograph, a gravelled foreground sets off a field of pipeline tanks. An archetypical landscape with a majestic stag standing in a wetland meadow, surrounded by bountiful, golden grain fields is painted on the most prominent of the tanks. Captioned "The Power of the Land," it advertises Enbridge Gas Distribution Ltd.[4] "*Build Your Nest in Western Canada*" also foregrounds wildlife—here a covey of grouse hones in on a nest

sheltered in a ripe grain field. In the middle ground, a train steams through swathed fields and, further in the background, a smokestack hints at incipient industries. In Conway's *Regina*, industry *is* the landscape. The power of the land resides less in the regenerative potential of the prairie than in supply and demand. The tank painting in *Regina* carries the insistent *pentimenti* of earlier immigration posters, and nature is represented as a heritage trophy, performing the emblematic function of reassurance.

In fact, Conway's landscapes are more complex than ecological critique. He borrows much from the strategies of the New Topographics, an influential group of photographers first assembled as a genre by William Jenkins for the exhibition *The New Topographics: Photographs of a Man-Altered Landscape* at the International Museum of Photography, Rochester, New York in 1975. Jenkins identified photographers who took an anti-aesthetic approach to the western landscape, at odds with the nature romance of Ansel Adams, Edward Weston, and Minor White. Instead, the New Topographics recorded, with deadpan acuity, the repetitive and banal features of newly constructed subdivisions, parking lots, strip malls, and industrial litter. Lewis Baltz, Robert Adams, Bernd and Hilla Becher, Joe Deal, Frank Gohlke, Nicholas Nixon, John Schott, and Henry Wessel Jr. documented western landscapes inscribed by the effects of human habitation, neither celebrating nor condemning. Conway's reappraisal of the New Topographics permeates all of his imagery, but is especially pronounced in *Weather station, Last Mountain Lake National Migratory Bird Sanctuary* (page 106) and *Bridge City Speedway, near Saskatoon* (page 49), which dispassionately record details of pipe, traffic barriers, fences, and the ubiquitous sterilant-saturated gravel. *Sewage lagoon,*

Waskesiu, Prince Albert National Park (page 78) looks like an engineer's model for an industrial park, while *Conquest, Rural Municipality of Fertile Valley* (page 9) is a bundle of receding perspective lines counterbalanced by a jet stream slicing a clear sky. The flotilla of pelicans in the middle of the image is as incidental as the camouflaged domestic architecture of Conquest, a village where geometry rules. In contrast, the plastic-coated round bales that dominate *Covered Hay Bales, Rural Municipality of Vanscoy* (page 26) are as industrial as marshmallows. Look at *Department of Highways trailer, Yellowhead Highway, Rural Municipality of Great Bend* (page 10), a commonplace, nomadic symbol of the province's notoriously crummy highways. Like the photographers of the New Topographics, Conway is magnetically drawn to ruin, or to ruin-in-the-making or to the messy by-products of progress, rather than to heroic spectacle.

In his preoccupation with industrial sites, Conway's work can be compared with that of Edward Burtynsky who photographs, in sweeping colour and intense detail, abandoned and working quarries, rail cuts, tailings ponds, and decommissioned oil tankers. Writing about Burtynsky's recent "before" and "after" photographs of Feng Jie, a city demolished to make way for the Three Gorges project, curator Blake Fitzpatrick analyzes how photographers respond to, and participate in continuous historical change:

The impossibility of any final photograph is not, however, a reflection of the photographer's abilities so much as it is a visual strategy that can comment upon a history that is itself unfinished, demanding of critical engagement and inherently insufficientæinsufficient in sustaining life and community and in preventing more and future disaster.[5]

While Conway does not literally repeat photographs, his photographs act as an historical update, revision or as witness to inexorable change, denoting the obverse of the idealized promise of the immigration posters. Given the short run of Saskatchewan's rural culture, the posters came to signify the surprise of failure. After all, for many immigrants the dream never materialized. Conway's spare landscapes are sequels to both the optimistic "before" of the settlement posters and subsequent utopian representations of Saskatchewan, such as Everett Baker's sunny documentary of the 1950s and 1960s.[6] Look at the elegiac tone of *Near Smuts* (page 45), or *Near Old Beaver Flat* (page 73), or *Rural Municipality of Bratt's Lake* (page 74), or *Highway 11, Louis Riel Trail, Davidson* (page 53). *Oil drums, Rural Municipality of Britannia* (page 41), with its luxuriantly oxidized iron surfaces and peeling paint, describes a weathered industrial site, and implies the invisible ruin of slowly decomposing and eroding communities, erased histories, and endangered species including soil species. Neither Conway nor Burtynsky are didactic. Though they use different pictorial strategies, both hinge their equivocating photography on industrial landscapes, leaving interpretation to the viewer. In Conway's case, his unflinching study of a post-pastoral rural recasts a place seen for too long through the distorting lens of nostalgia.

To gain perspective on the notion of a post-pastoral rural, I called my brother Graham and Shelley, his business partner and wife, who farm near Central Butte, Saskatchewan. After the obligatory weather chat our talk turned to the rural landscape—theirs and mine. Our divergent views of land originate in a simple fact: they stayed and I left. Graham and Shelley inhabit a single-minded "countryside" largely comprised of uniform growth periodically interrupted by the grey pallor of chem-burnoff. Their topography has become increasingly geometric with the development of the Global Positioning System (GPS) and robotized farming: sloughs have been drained, hillocks levelled, shelter-belts and aspen groves bull-dozed and burned, stone piles buried. The preoccupations of history and biome that reside in crumbling landmarks and geological features—fencerows, buildings, school yards, water-ways, wetlands—have no place in agribusiness Eden. This "No Place" is precisely where the rural landscape of my imagination lives. It is a love-hate conglomeration of affection for the home quarter, pressed between the landscapes of Corot and Constable, Dorothy Knowles and Reta Cowley. At the same time, I admire Robert Smithson's earthworks and contemporary land-sited art, and appreciate the working landscape of geometry, uniformity and utility. It is a profoundly minimalist aesthetic, closer to an Agnes Martin or Art McKay painting than the landscape cliché on the Enbridge tank in *Regina*. Conway faithfully attends to the agribusiness landscape, yet achieves a rapprochement with nostalgia-addled rural expatriates.

Looking into Conway's stark photographs, an unruly bucolic asserts itself. The Quonset hut in *Former Hamlet of Winter, Rural Municipality of Senlac* (page 117) is surrounded by weedy trees, and *Rural Municipality of Vanscoy, No. 1* (page 21) with the sign "Superb" leaping out from a vigorously uniform field of barley, has a furry horizon line of distant aspens. Just beyond the frame, Conway's Saskatchewan continues as a place of rampant contradiction, where agribusiness, biotech, mining and petrochemical industries, a First Nations renaissance, tourism, suburbia, a growing organic farming industry, and an active cultural industry, all cohabit a landscape being seeded back to indigenous prairie species.

Conway asks us to think about a drained agrarian demographic, to reassess the naked opportunism of rural capitalism's dream, and to consider how post-colonial narrative exhaustion and neo-conservative political agitation have fundamentally changed concepts of land, place, and history. At the same time, Conway's essay reveals his deep affection for a landscape subject to powerful emotional undertows. He is obviously susceptible to rural culture, its humour, perverse optimism, and canny circumspection. John Conway's deictic photographs, odd and familiar, disrupt expectation and prompt self-reflexive inquiry in the face of an unpredictably coalescing future. They participate in a mammoth mythopoetic rewrite, just beginning.

NOTES

1. Joseph Mali, *Mythistory: The Making of a Modern Historiography* (Chicago: The University of Chicago Press, 2003). Mali argues mythologies are a critical component of a society's sense of identity.

2. Caroline Heath, "When fact meets fantasy," in *The Middle of Nowhere: Rediscovering Saskatchewan,* Dennis Greunding ed. (Calgary: Fifth House Ltd., 1996), 208.

3. Farm chemical and implements dealers, banks and credit unions, tourism brochures and real estate websites all retread the images of a golden pastoral landscape.

4. Enbridge Gas Distribution Ltd. was awarded the Environmental Practice of the Year award at the 2001 Financial Times Global Energy Awards.

5. Blake Fitzpatrick, *Disaster Topographics* (Toronto: Gallery TPW, 2005). http://www.photobasedart.ca/html/publications/essays/download/BlakeFitzpatrick.pdf

6. Heather Smith, *Everett Baker: Picturing a Utopian Reality* (Moose Jaw: Moose Jaw Museum and Art Gallery, 2002).

Photographs

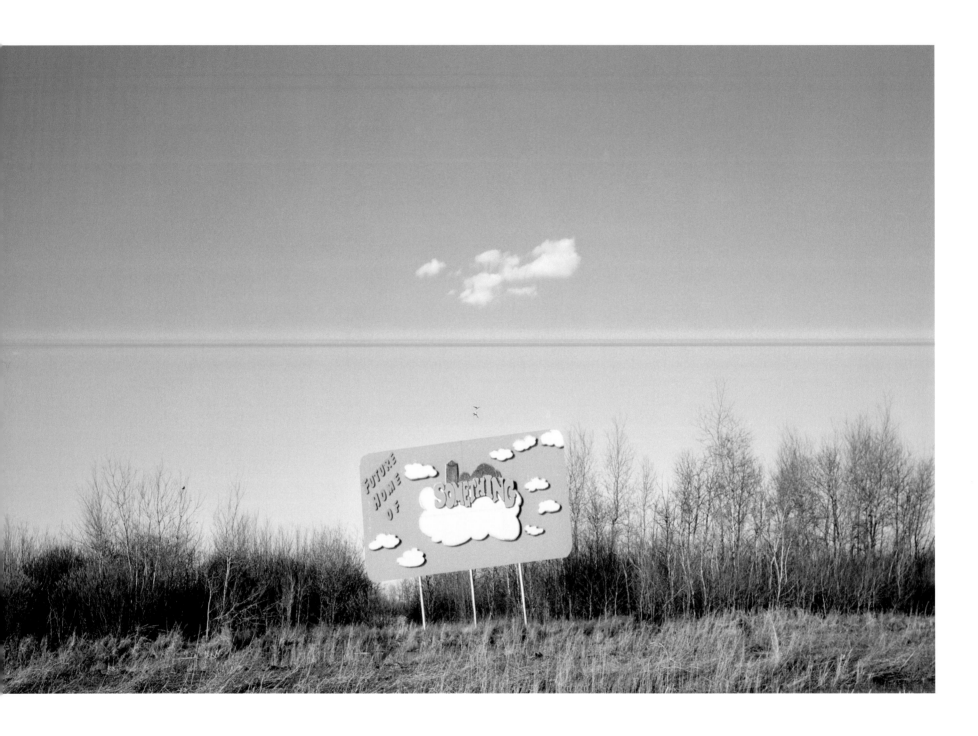

Yellowhead Highway, Rural Municipality of Great Bend

In his recent history of Saskatchewan, Bill Waiser points to several challenges that have faced the province: retaining its people, especially young people; addressing the unrelenting decline of family farming and of rural Saskatchewan, and the related need for greater economic development outside of Saskatoon and Regina; and, most critical of all, securing a good place for the growing Aboriginal population.[1] There are no road signs showing a clear way through these challenges and into the future.

Saskatchewan has been called "next year country," a slogan probably first used by early sodbusters on the prairie: "this year was hard, but next year will be better." This sign, "Future Home of...Something" implies some of the same optimism, even daring.

The sign is now gone. There is nothing on the land.

Rural Municipality of White Valley, No. 1

*Scattered on this ranchland in southern Saskatchewan
are cattle and hay bales. In some parts of the far south,
rangelands remain where livestock graze only on native
grassland, where the prairie has escaped the plow because
the soil is too dry or too thin.*

*Sharon Butala, who lives near where this picture was
taken, writes:*

> The Great Plains are a land for visionaries, they induce
> visions, they are themselves visions, the line between
> fact and dream is so blurred.... Sky and land, that is all,
> and grass, and what Nature leaves bare the human
> psyche fills.[2]

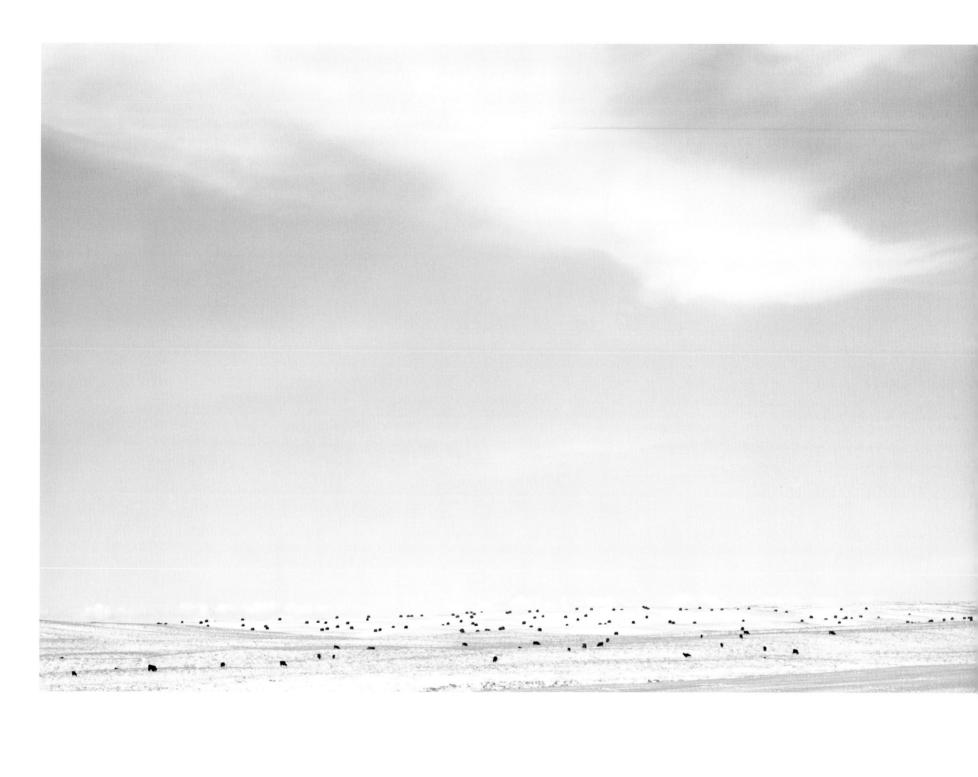

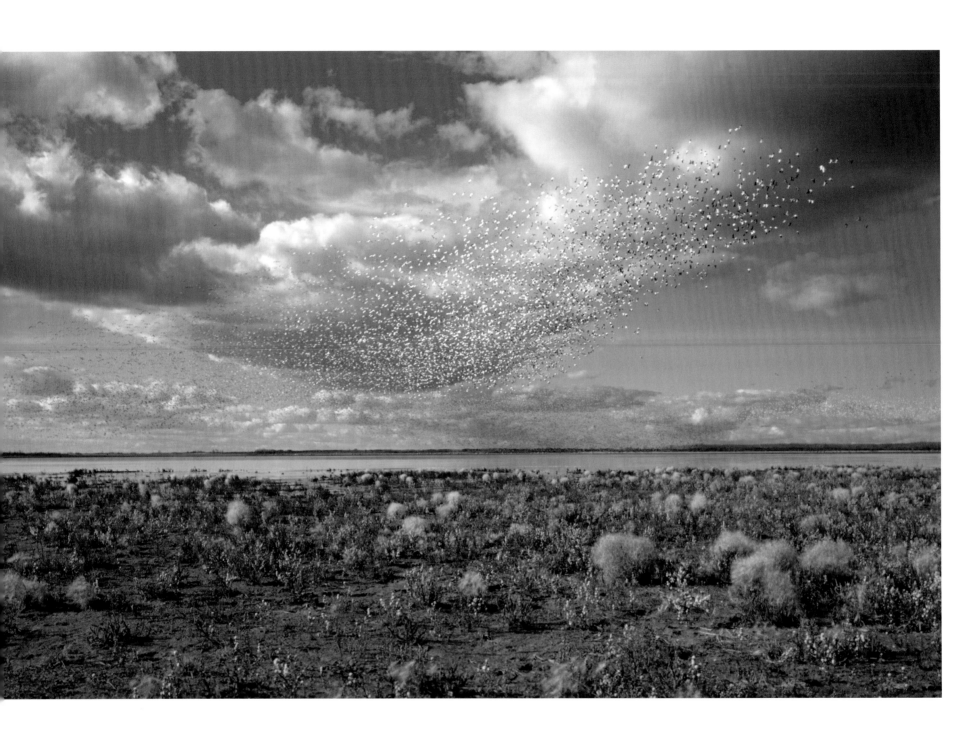

Snow Geese, Duck Lake

Blizzards of snow geese and other waterfowl can be seen in the fall as they stop to gorge themselves on spilled grain left during harvest. There were thousands more snow geese than seen here at Duck Lake on this fall day. And, there was a lone golden eagle in the vicinity. Before the eagle was close enough for me to see, the geese would take flight from Duck Lake, all at once.

Conquest, Rural Municipality of Fertile Valley

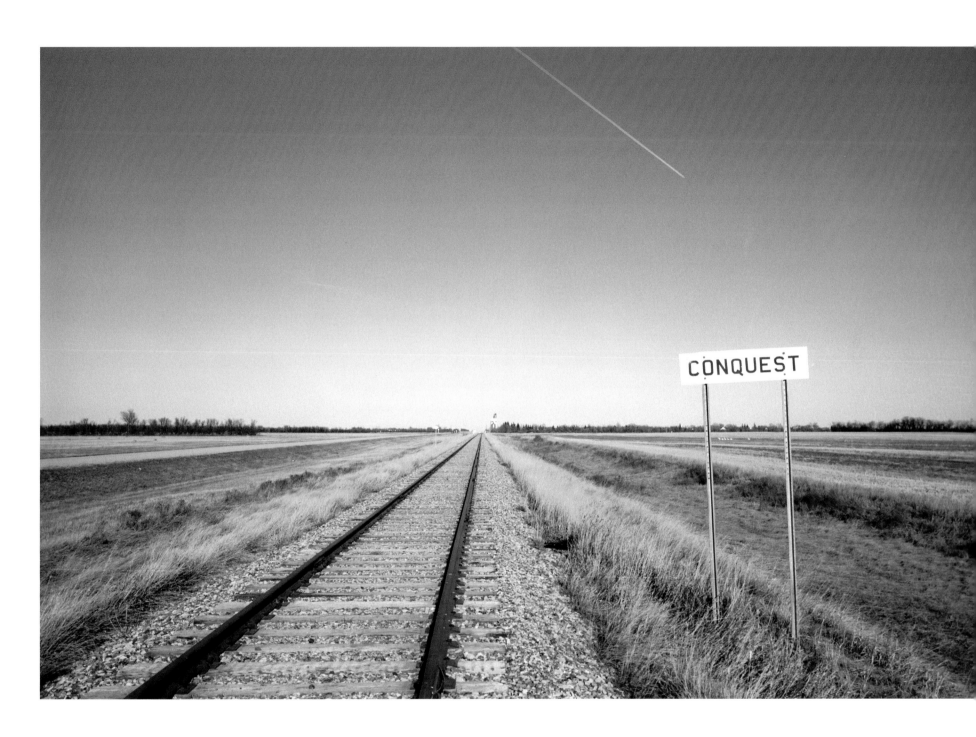

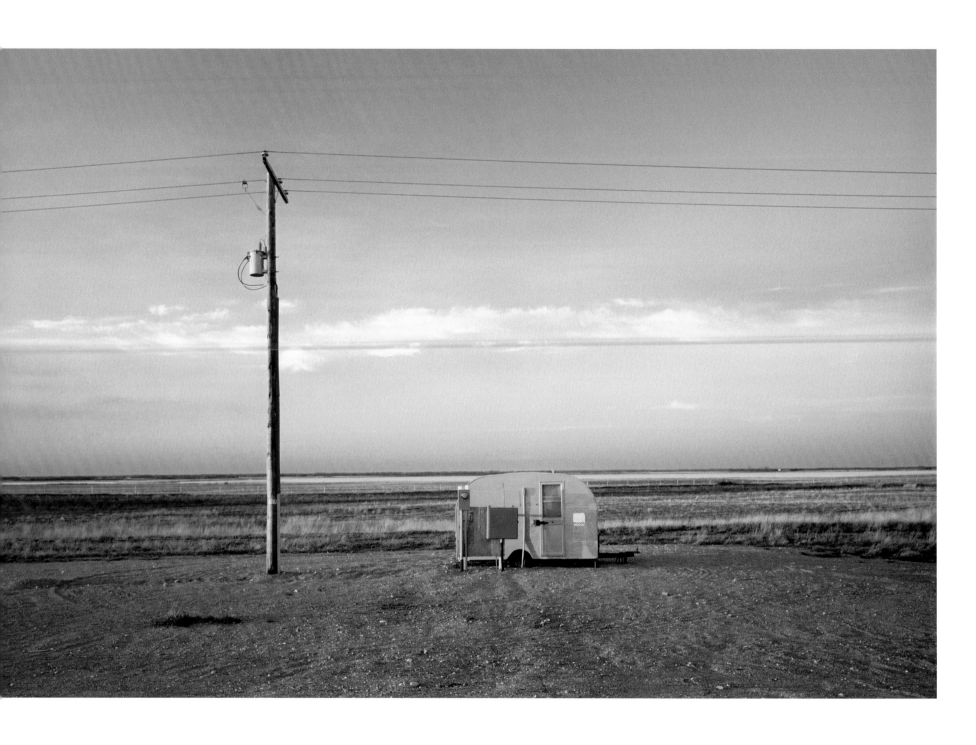

Department of Highways trailer, Yellowhead Highway, Rural Municipality of Great Bend

Rural Municipality of Lost River

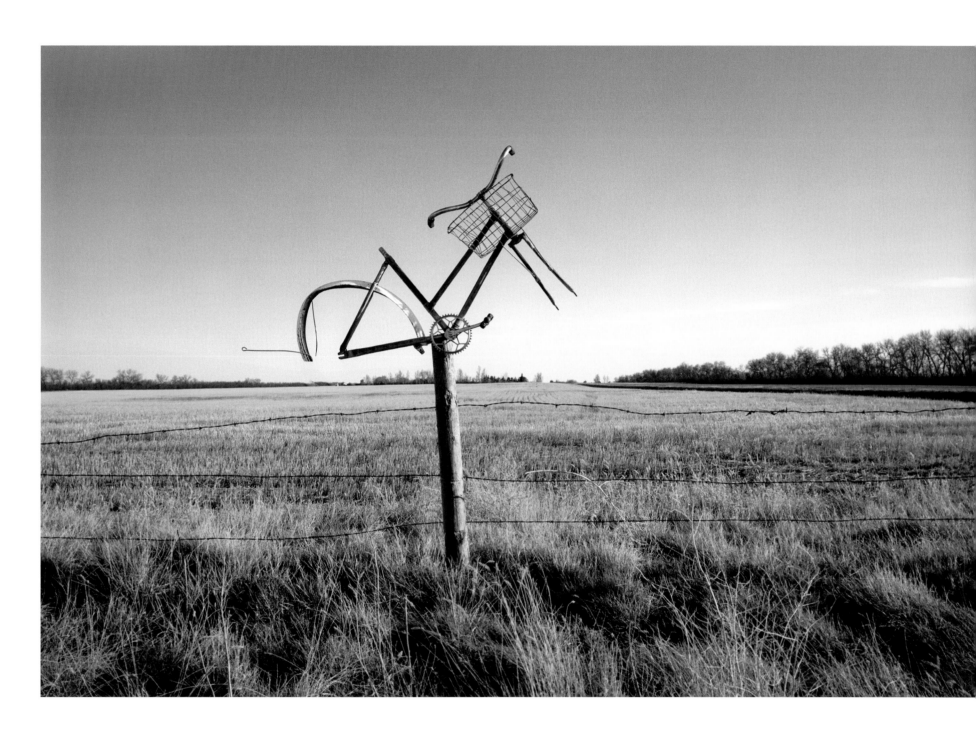

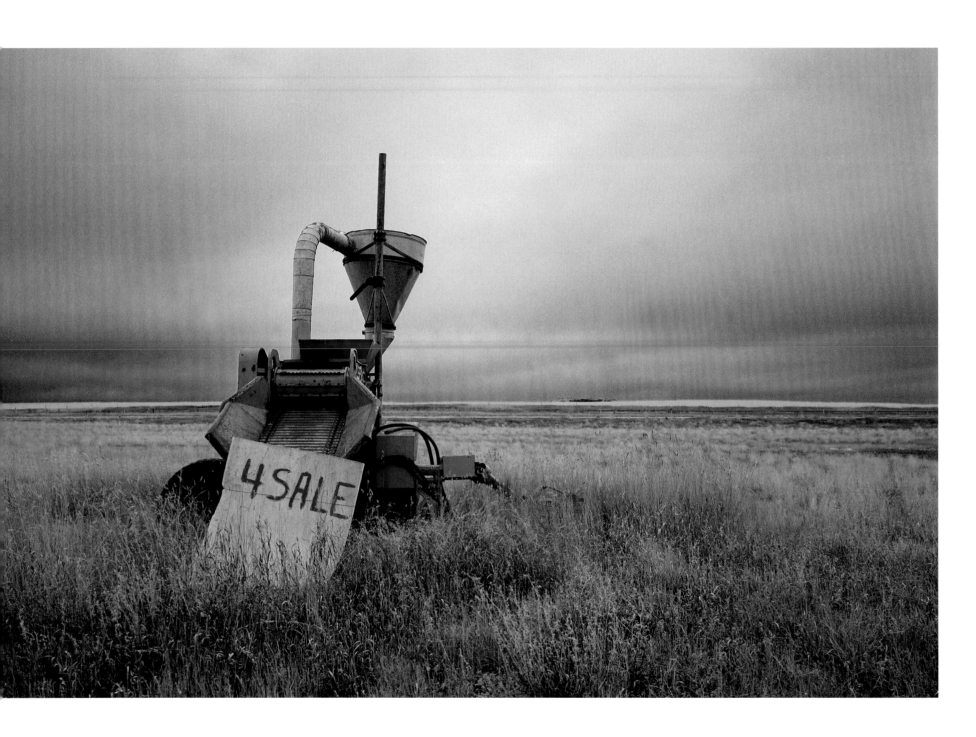

Highway 11, Louis Riel Trail, near Bethune

Many homesteaders were forced from the land in early years. A poem, faintly scrawled on the door of an abandoned shack in 1906 read: "I'm twenty miles from water, and forty miles from wood; So I'll leave you now my happy home, I'll leave you now for good." [3] Long the sustenance of Saskatchewan people, the family farm has been slowly, unrelentingly dying for many decades.

Wheat, once king, has a lower value now than other grains, oilseeds, pulse and other specialty crops. The international market price for wheat has fallen from around $12 per bushel in 1916 to around $5 in 2000 (in constant 2000 dollars). When we pay $2 for a loaf of bread at the grocery store, the farmer gets around twelve cents.

The number of farms peaked in 1936 at 140,000; most occupied a quarter-section of land (160 acres). [4] Today, only about one-third of these family farms remain, and the size of the average farm has grown to over 1,300 acres (about two square miles of land). Agriculture now accounts for only about seven percent of the gross domestic product in the province.

Rural Municipality of Hoodoo

GREENLEAF PUBESCENT
WHEATGRASS

Rural Municipality of St. Louis, No. 1

Rural Municipality of Vanscoy, No. 1

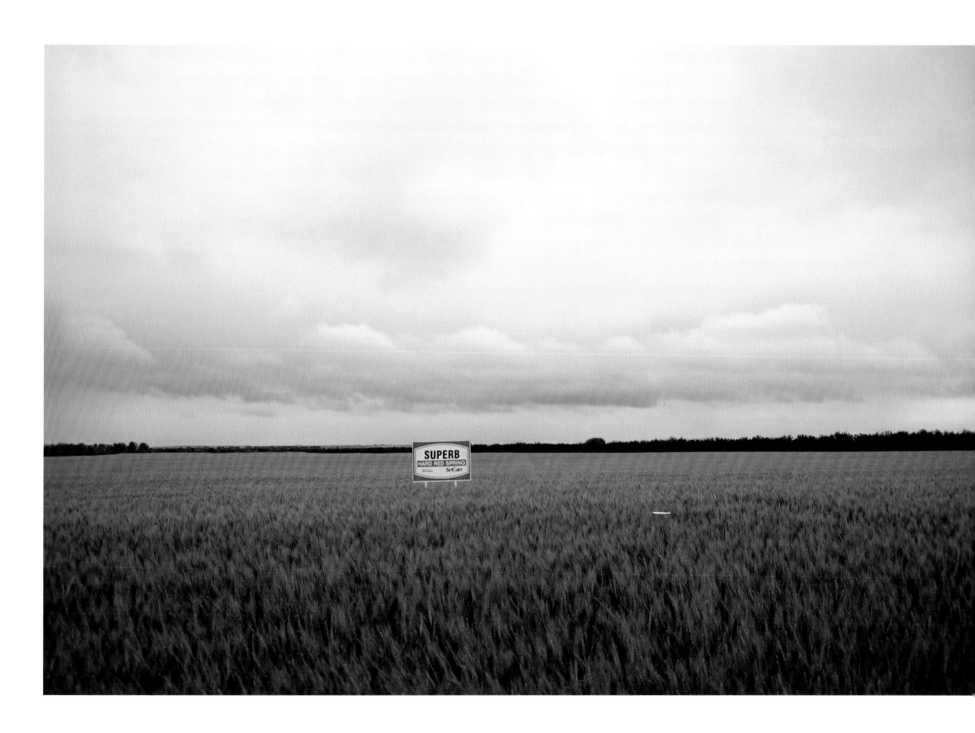

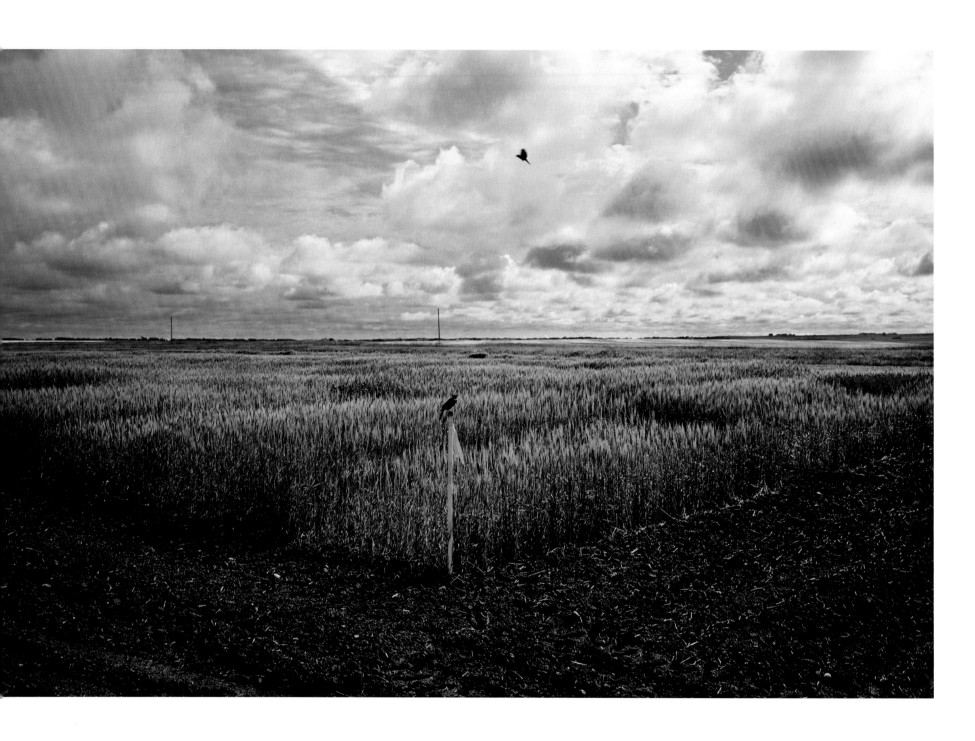

Experimental barley, near Saskatoon

Rural Municipality of Aberdeen

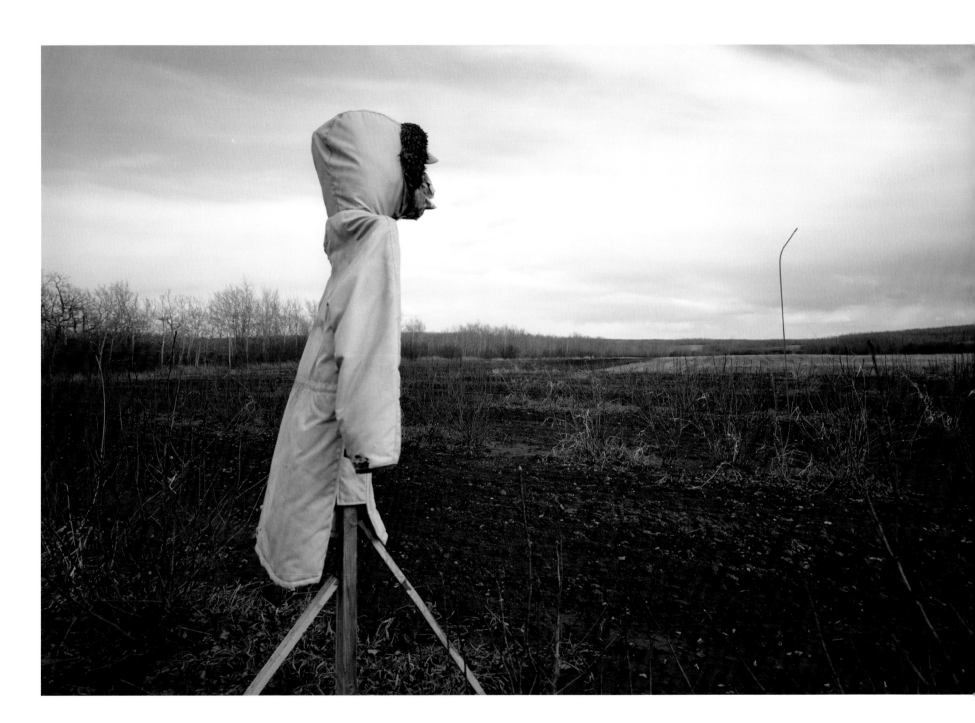

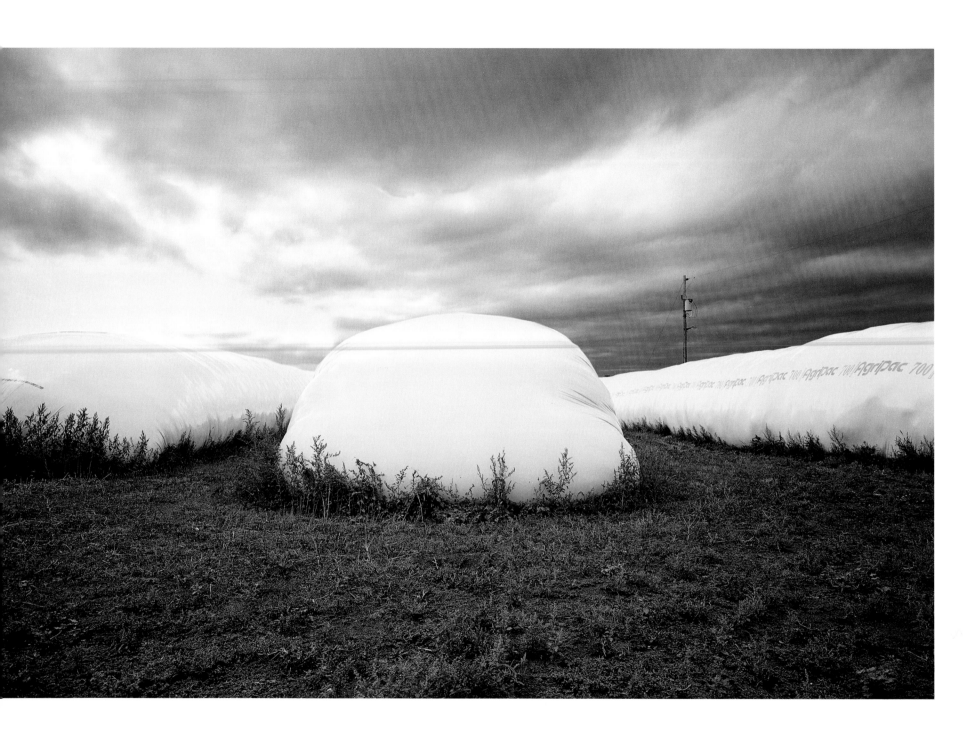

Covered hay bales, Rural Municipality of Vanscoy

Experimental canola No. 1, near Rosthern

In July, the landscape glows with the saturated yellow of the canola flower. An edible oil seed crop bred from rape seed, canola was developed on the prairies in the 1950s.

Experimentation continues today. To isolate individual experimental plants, each is shrouded in a mesh netting, propped up here by a wood stick topped with a pop can— to round off sharp edges—and held together by a clothes pin. A higher-tech version is pictured in Experimental canola No. 2, AgQuest, near Grandora *(page 33).*

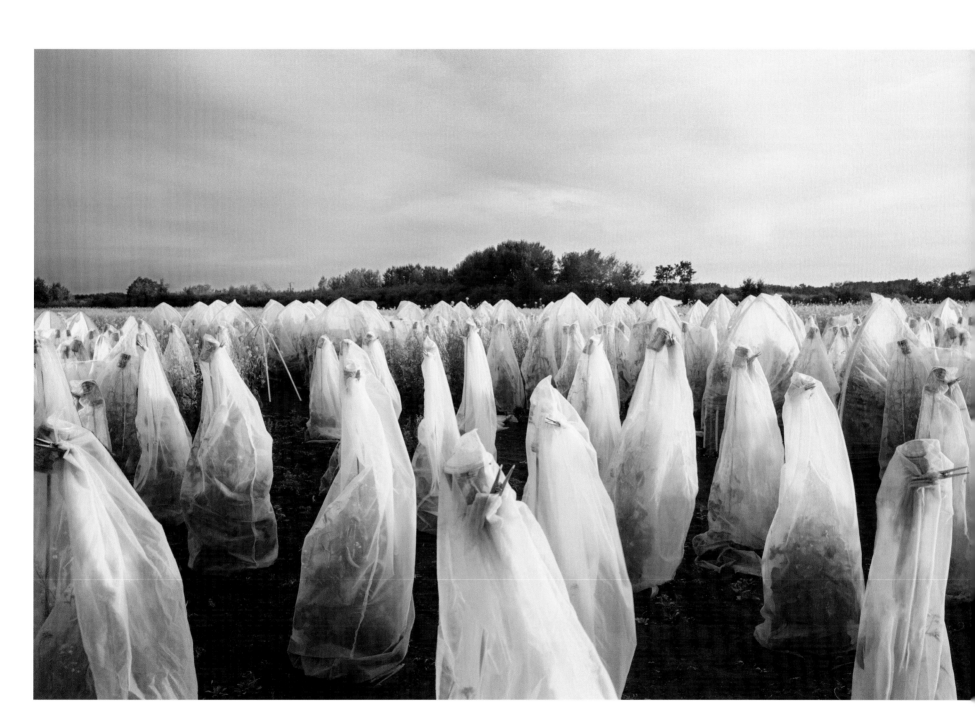

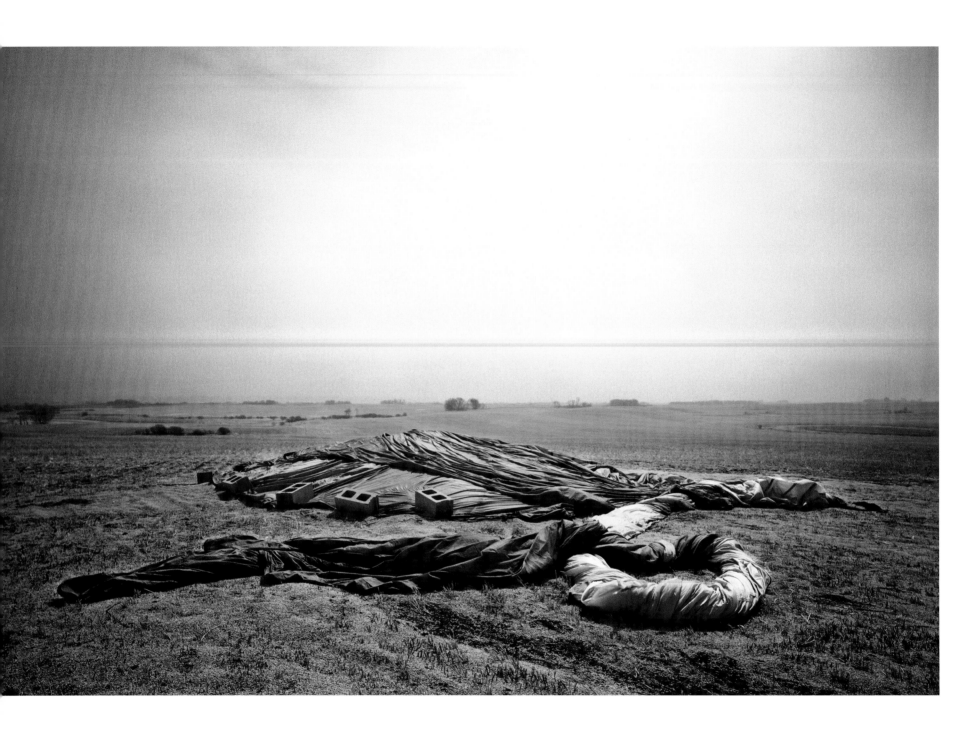

Grain tarp, Rural Municipality of Hoodoo

When shown Canadian photographs alongside those
made in Britain, the United States, and elsewhere,
whether documentary photographs or portraits or
landscapes, the almost universal response of [students
in the History of Photography course I was teaching]
was that they could see "nothing" in these images,
that there was "nothing there."

—*Penny Cousineau-Levine* [5]

Experimental canola No. 2, AgQuest, near Grandora

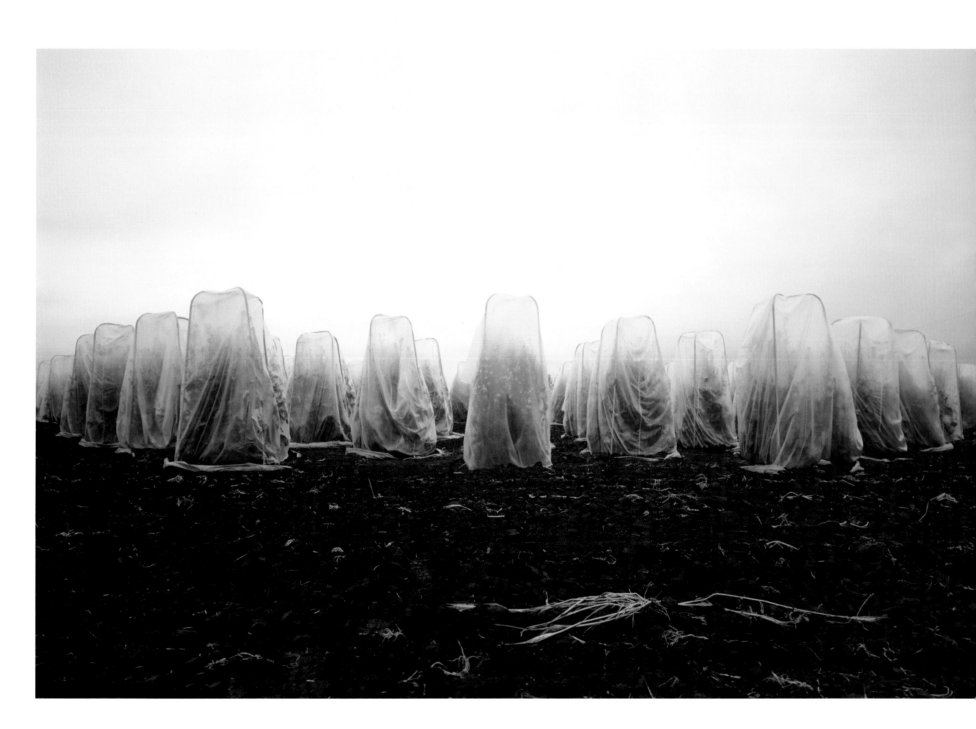

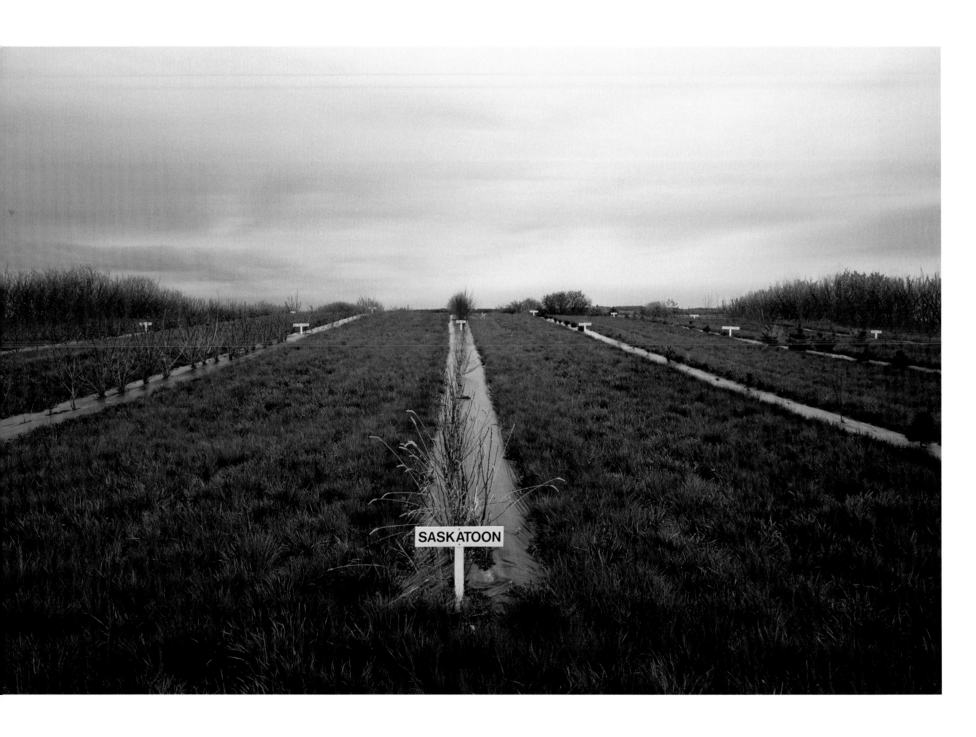

Rural Municipality of St. Louis, No. 2

Britain's Food Standard Agency took saskatoon berry prod-
ucts off store shelves in 2004 and ordered a full pre-market
safety evaluation, stating there is no evidence the berries
are safe to eat. Saskatchewan's agriculture minister replied
that the Royal Family eat saskatoons when they visit, and if
the berries are good enough for the royals, they should be
good enough for commoners. They are now back on the
shelves, I'm told.

Rural Municipality of Vanscoy, No. 2

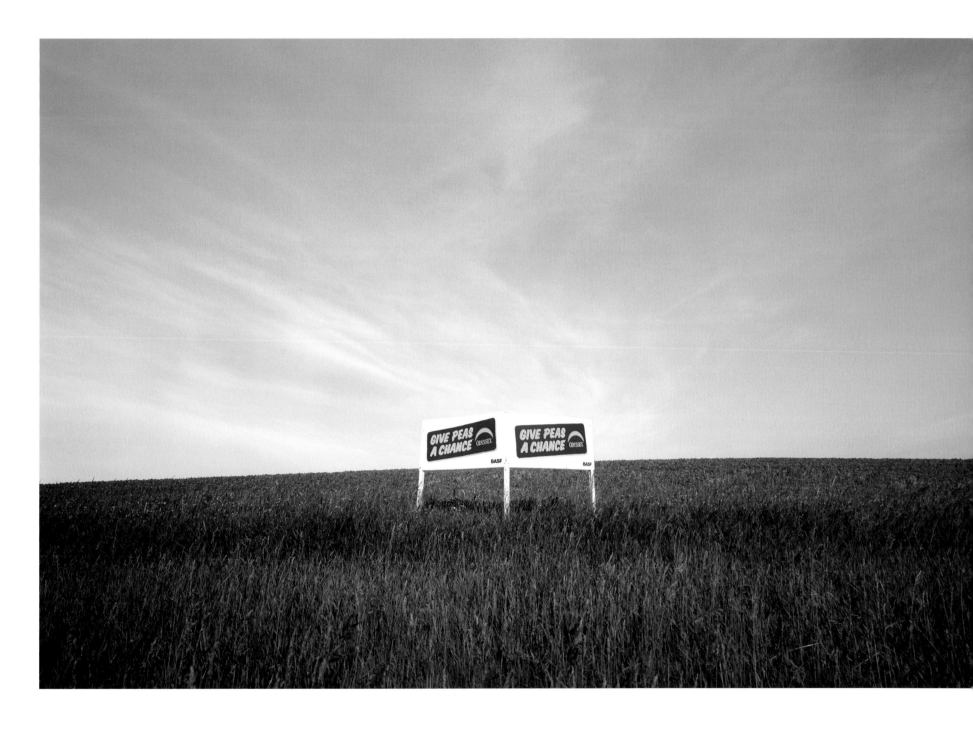

Rural Municipality of Perdue, No. 1

Oil drums, Rural Municipality of Britannia

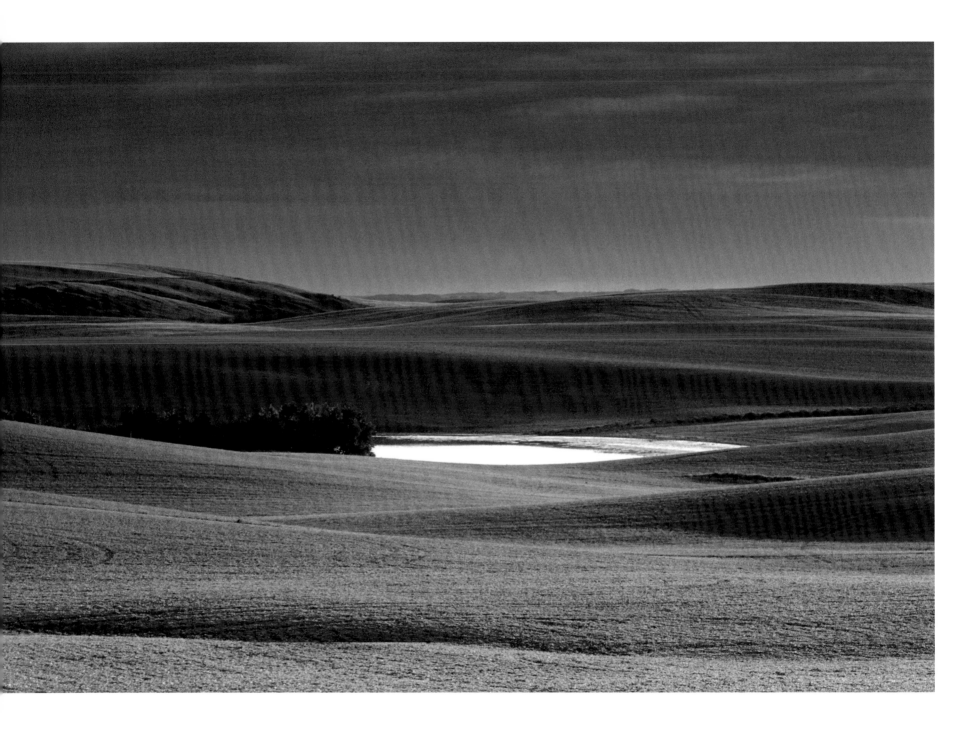

Canola, near St. Denis

This rolling field of canola, green before it had flowered,
with a luminous slough in the middle, admittedly, does not
look much like prairie. The editor in Don Kerr's poem,
"Editing the Prairie," might just approve.

> Well, it's too long for one thing
> and very repetitive.
> Remove half the fields.
> Then there are far too many fences
> interrupting the narrative flow.
> Get some cattlemen to cut down those fences.
> There's not enough incident either,
> this story is very flat.
> Can't you write in a mountain
> or at least a decent-sized hill?
> And why set it in winter
> as if the prairie can grow nothing
> but snow. I like the pubic bush
> but there's too much even of that,
> and the empty sky filling all the silences
> between paragraphs is really boring.
> I think on due consideration
> we'll have to return your prairie.
> Try us again in a year
> with a mountain or a sea or a city. [6]

Near Smuts

This entire swath of country is pocked with millions of mostly small, knee-to-waist-deep depressions—called potholes or sloughs—that are a legacy of the most recent glaciation.... They depend mainly on snowmelt, rather than rain, to replenish their supply of water.... Vitally important as sources of protein for both resident and migratory birds, these wetlands are perhaps most famous as the "duck factory" of North America.

—*Candace Savage* [7]

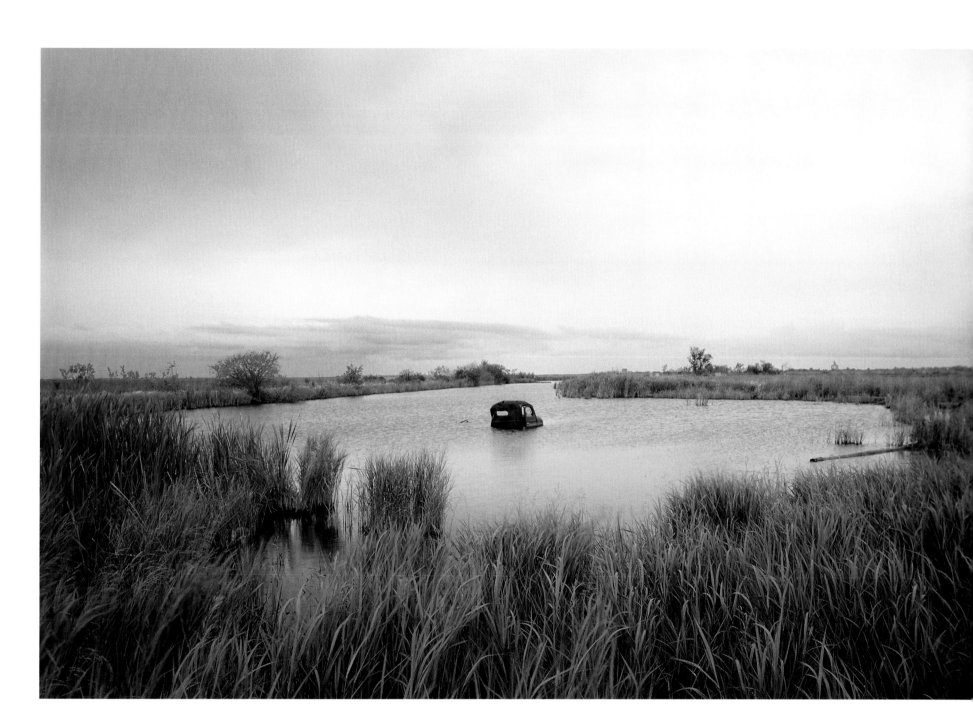

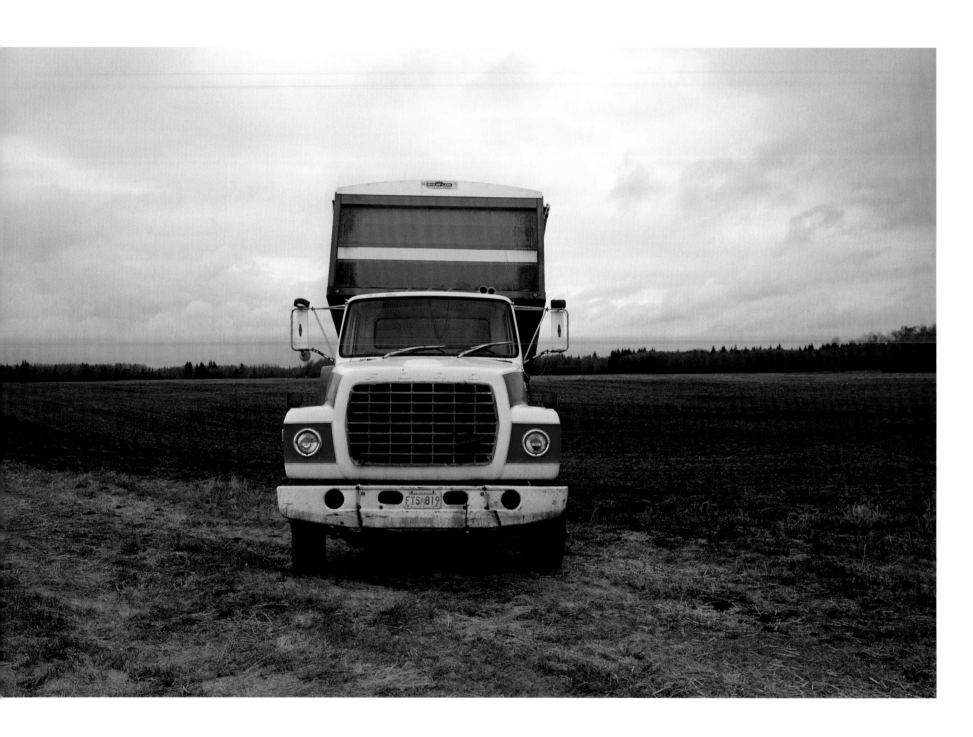

Rural Municipality of Fish Creek

Fish Creek, on the South Saskatchewan River, was the site of a battle in 1885 as Gabriel Dumont led Métis in an ambush of the Canadian Militia on their way to Batoche to put down the Northwest rebellion. Following their defeat at Batoche, and after finding neither the necessary capital nor the inclination for homesteading, many Métis people drifted back to crown land on the sides of road lines and roads where they built shacks and were known as the Road Allowance People.

Bridge City Speedway, near Saskatoon

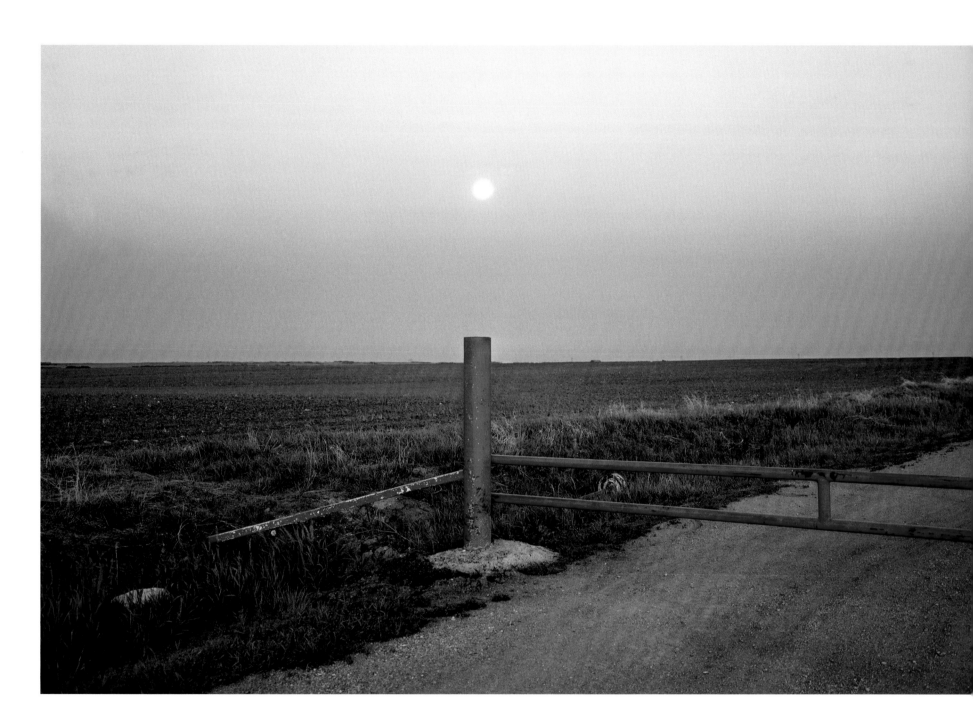

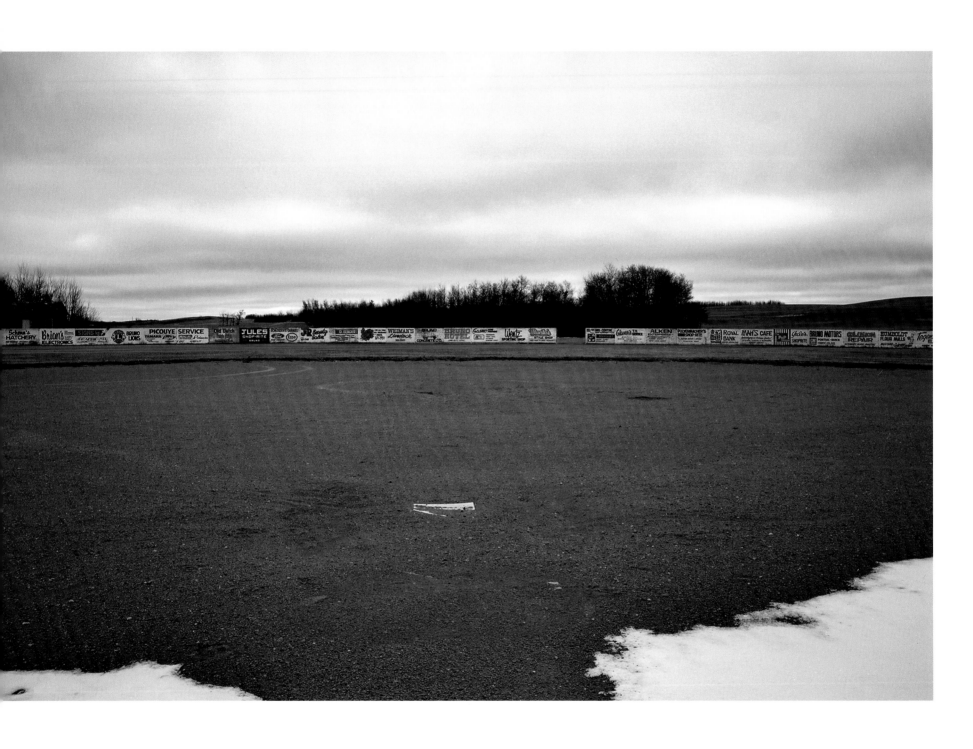

Near Bruno

At the edge of every small town there is a baseball field. In most towns today, only the backstops remain as memories of games once played. Les Crossman used to write old base-ball stories in every issue of the Saskatchewan Historical Baseball Review.

I remember that two lazy fly balls that should have been caught landed near the centre fielder and were never retrieved from the long grass. In the absence of ground rules covering balls lost in the abundant hay crop, both batters were credited with home runs....
[The umpire] said in a loud voice, "Game called on account o' bootleggers and lost balls."

—*Les Crossman* [8]

Highway 11, Louis Riel Trail, Davidson

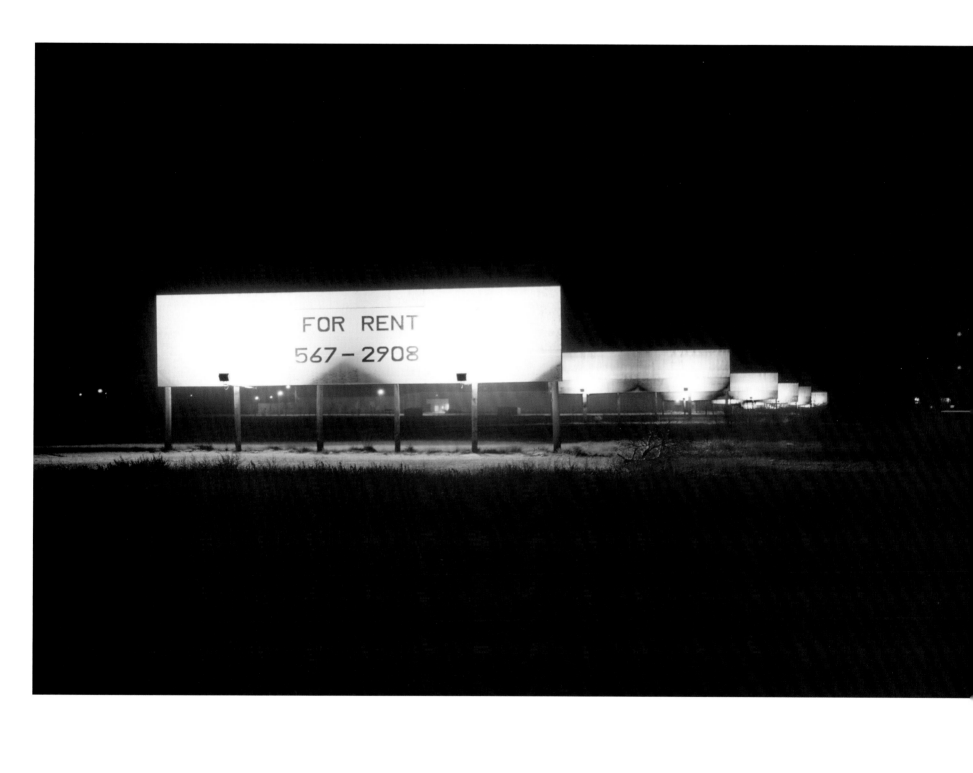

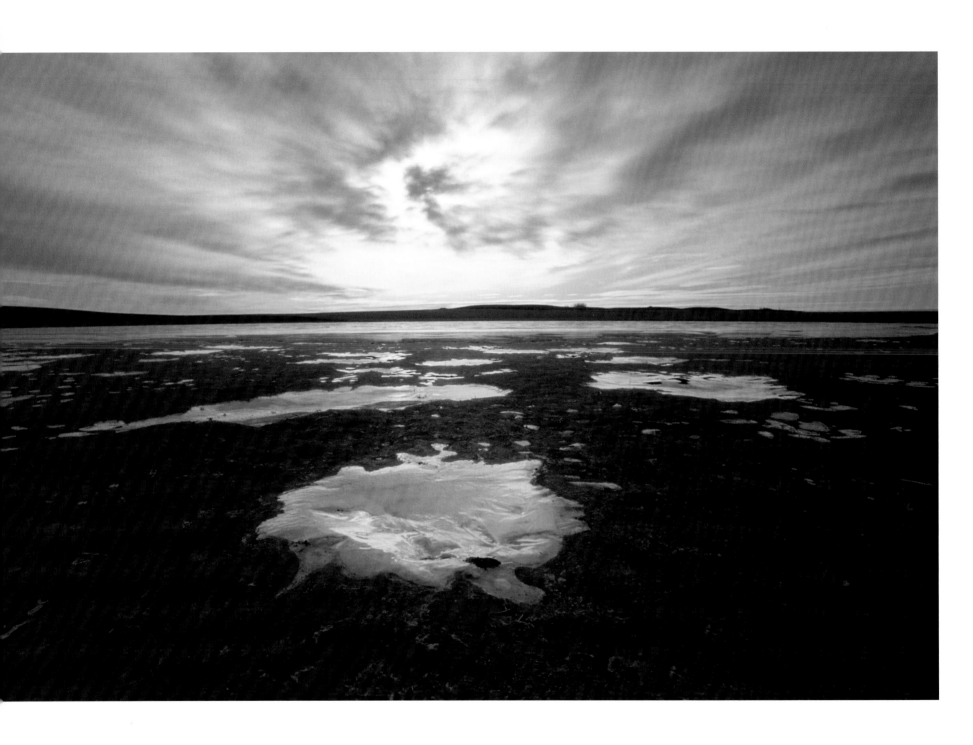

Rural Municipality of Viscount

Gravel pile, Rural Municipality of Eagle Creek

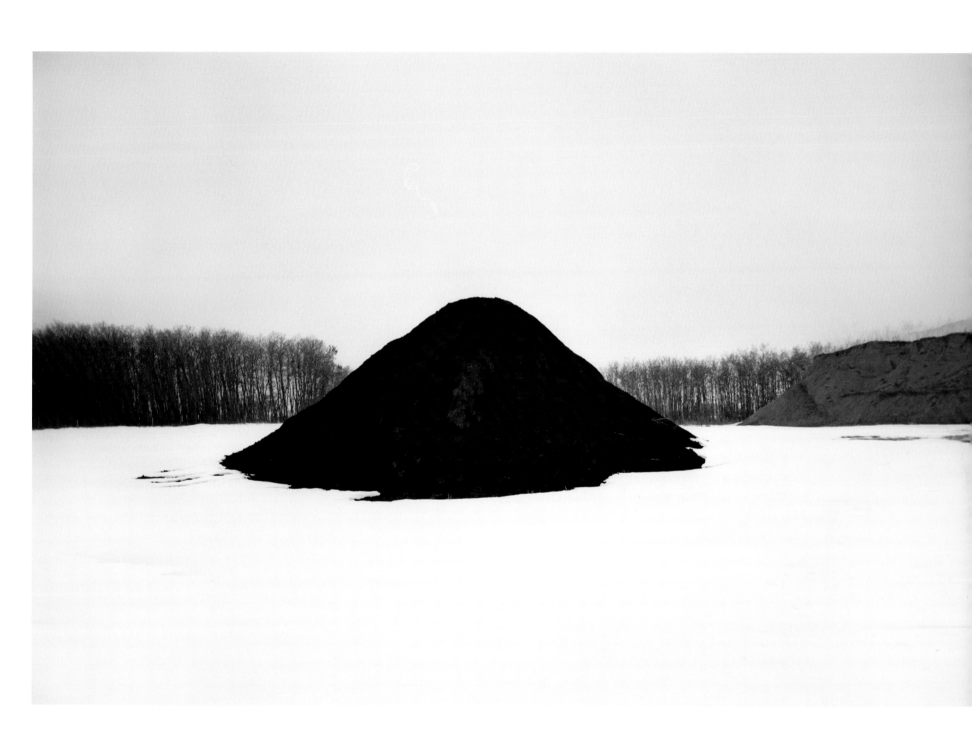

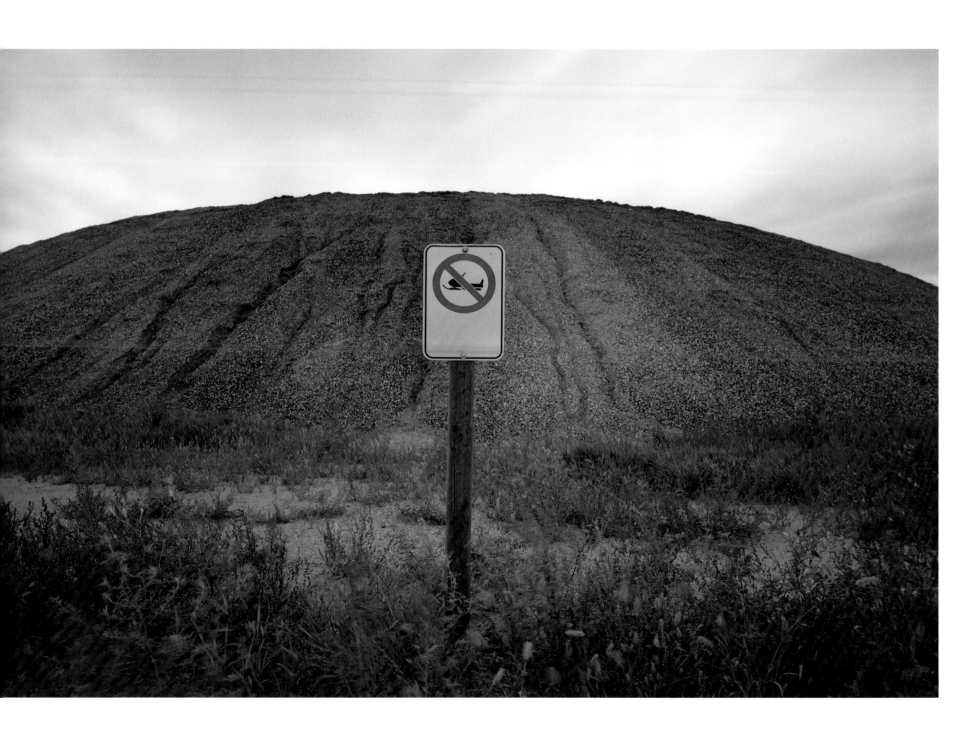

Rural Municipality of Perdue, No. 2

Highway 42, Rural Municipality of Eyebrow

Politics get personal in Saskatchewan. Premier Roy Romanow came close to losing the 1999 election for the New Democratic Party. Almost every rural riding was lost— crumbling rural roads and highways were an issue.

There are more roads per capita here than just about anywhere; some are not to be driven without a helmet. I remember, fondly now, when I first drove into a Saskatchewan pothole in 1973. I had just crossed the border on the Yellowhead highway, leaving Manitoba and all that was east was forever behind me. My head hit the roof and the car radio stopped.

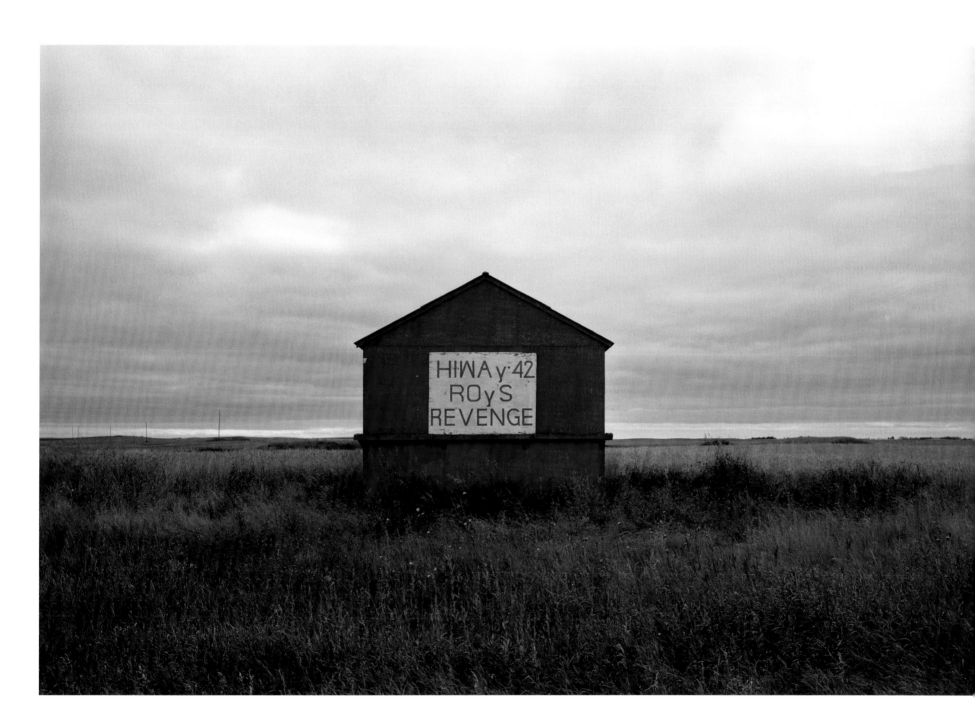

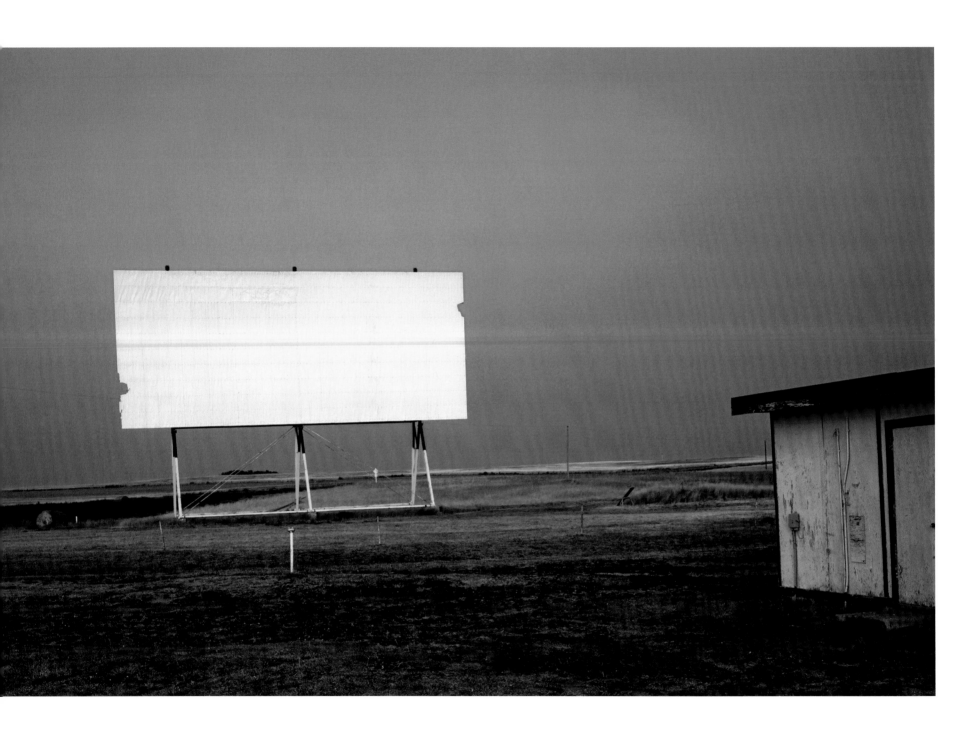

Drive-in, near Kyle

Apparently there are only about sixty drive-in movie theatres still operating in Canada. The last time I was at the one near Kyle, not that long ago, the drive-in was open for summer-time business. Fargo *was playing.*

Métis recreation park, near Batoche

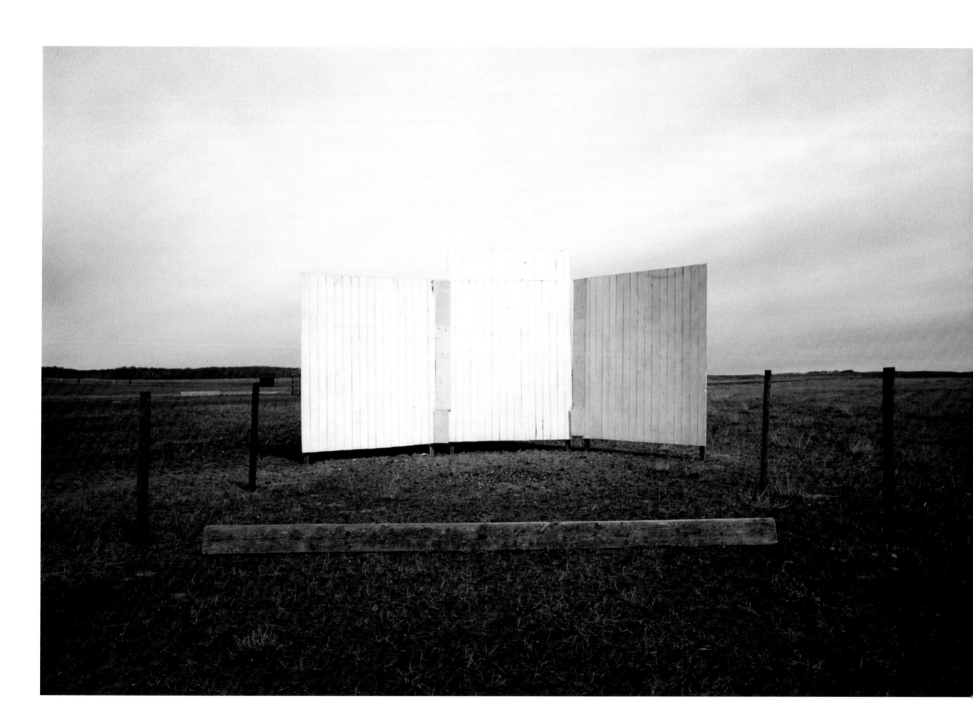

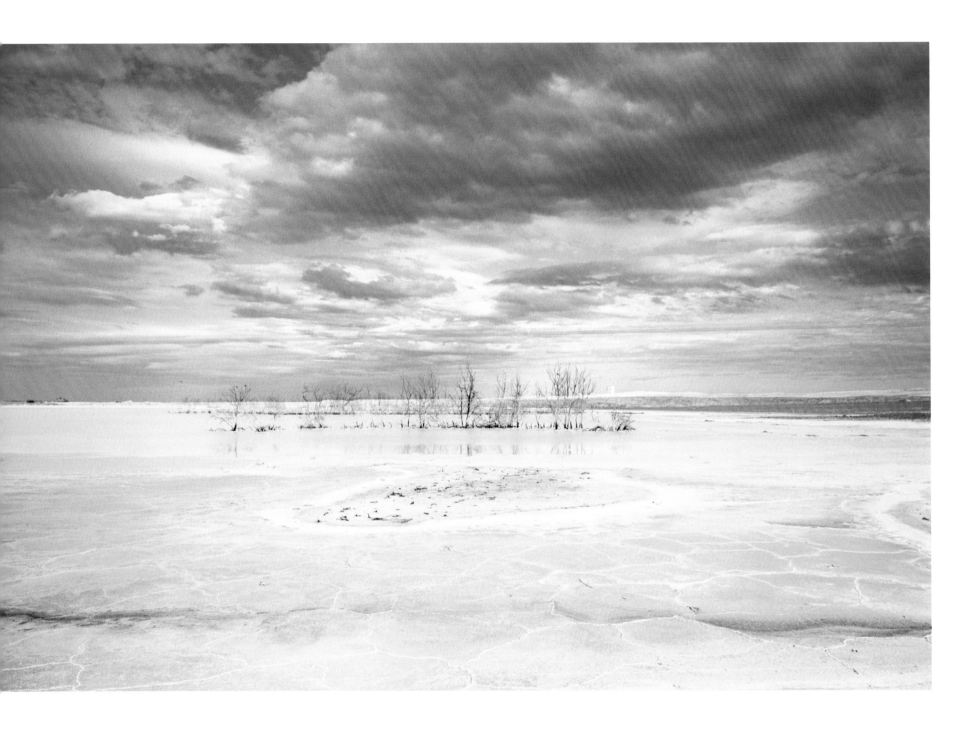

Tailings, Potash Corporation of Saskatchewan, Allan Division

Saskatchewan could supply the world demand for potash, a potassium-rich compound used in fertilizers, at current levels for several hundred years. Potash is the largest mining industry in the province; uranium is the second largest.

Near Imperial, Rural Municipality of Big Arm

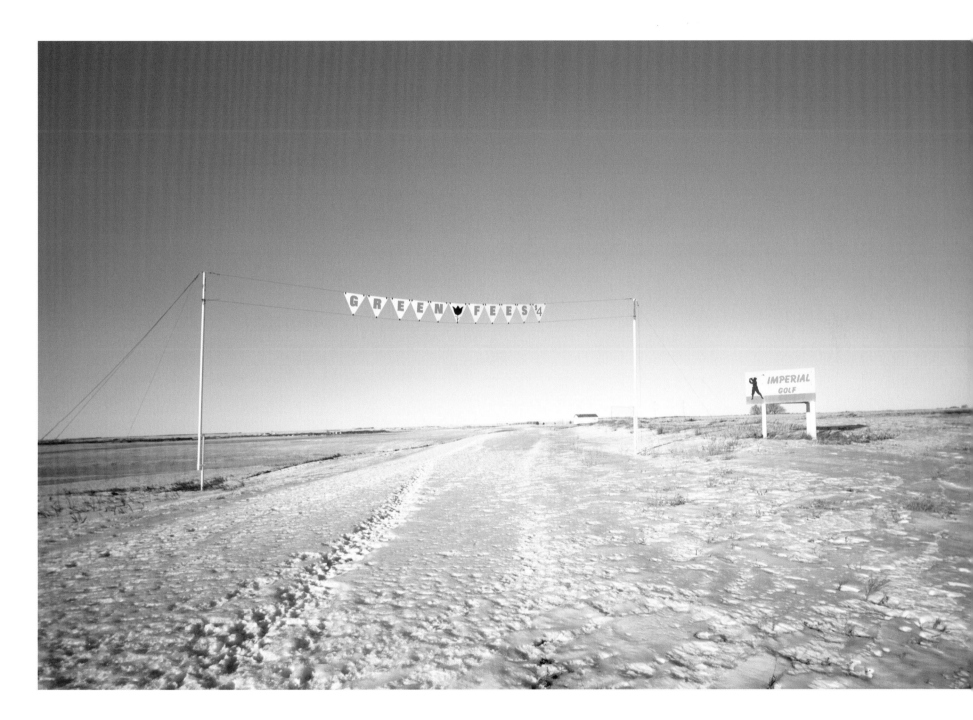

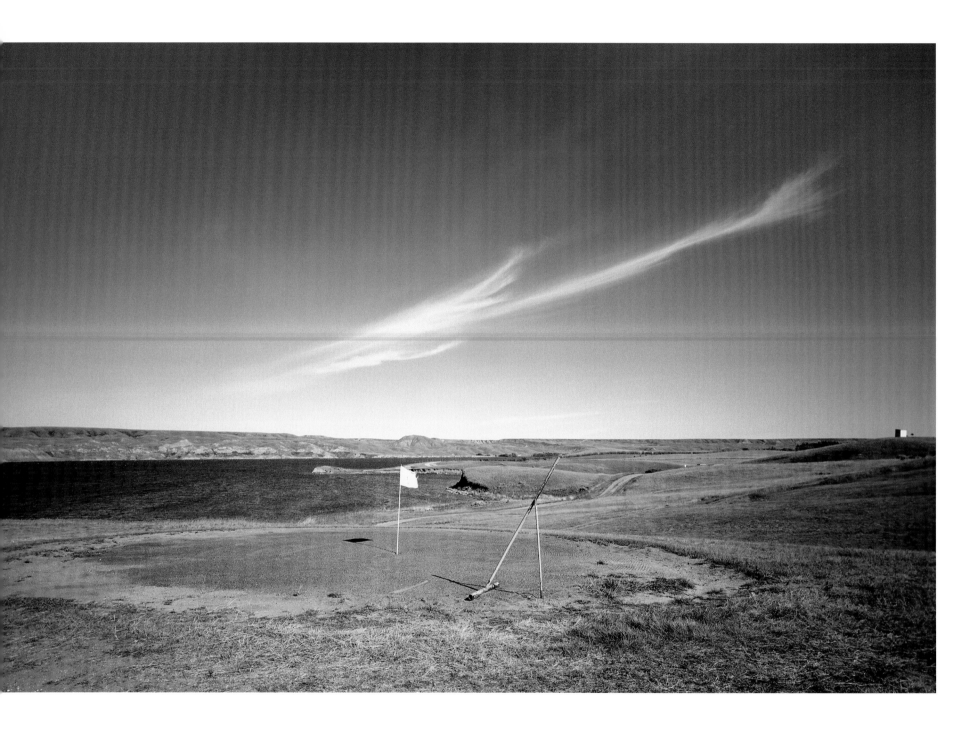

Sand green No. 4, Beaver Flat Golf Course

There are more golf courses per capita in Saskatchewan than just about anywhere in the world. There are probably more in Japan. But green fees there must be at least $1,000. Four bucks is hard to beat. Most of the golf courses in rural Saskatchewan were built and are run by the local community, golfing being the "people's recreation" during the off-season for curling.

Near Old Beaver Flat

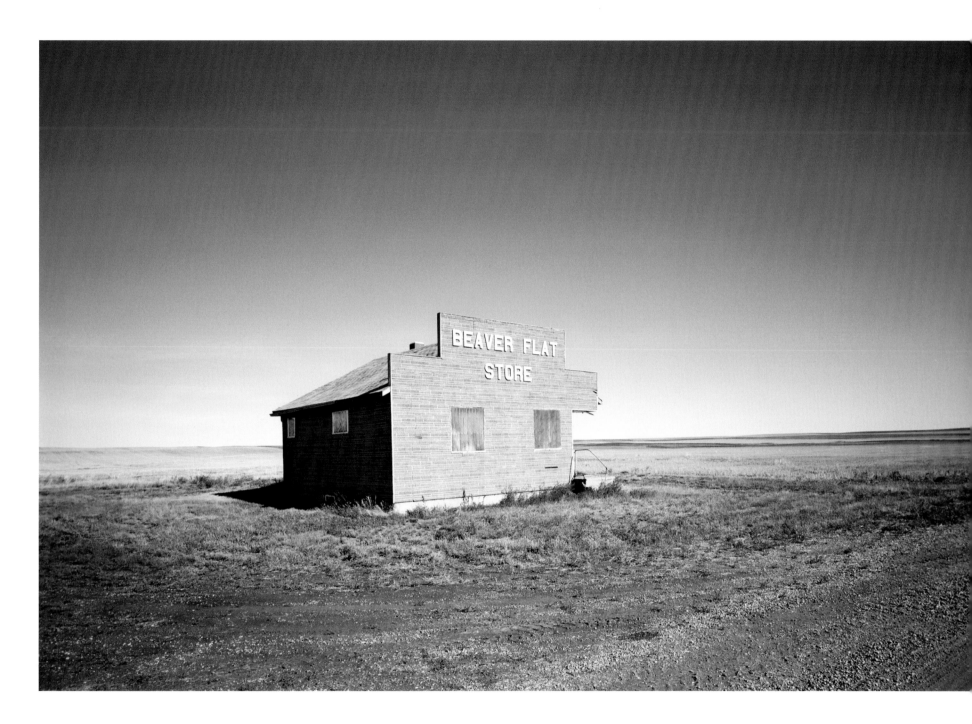

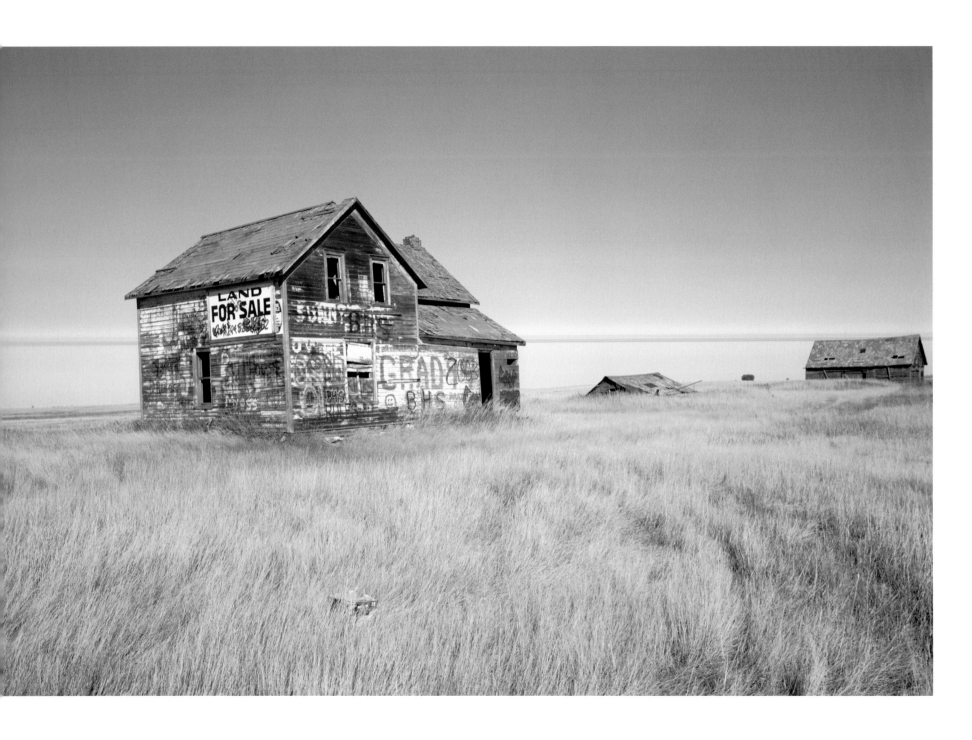

Rural Municipality of Bratt's Lake

Rural Municipality of Poplar Valley

I never did drive down this road to what was once Paradise Lake. I wish I had.

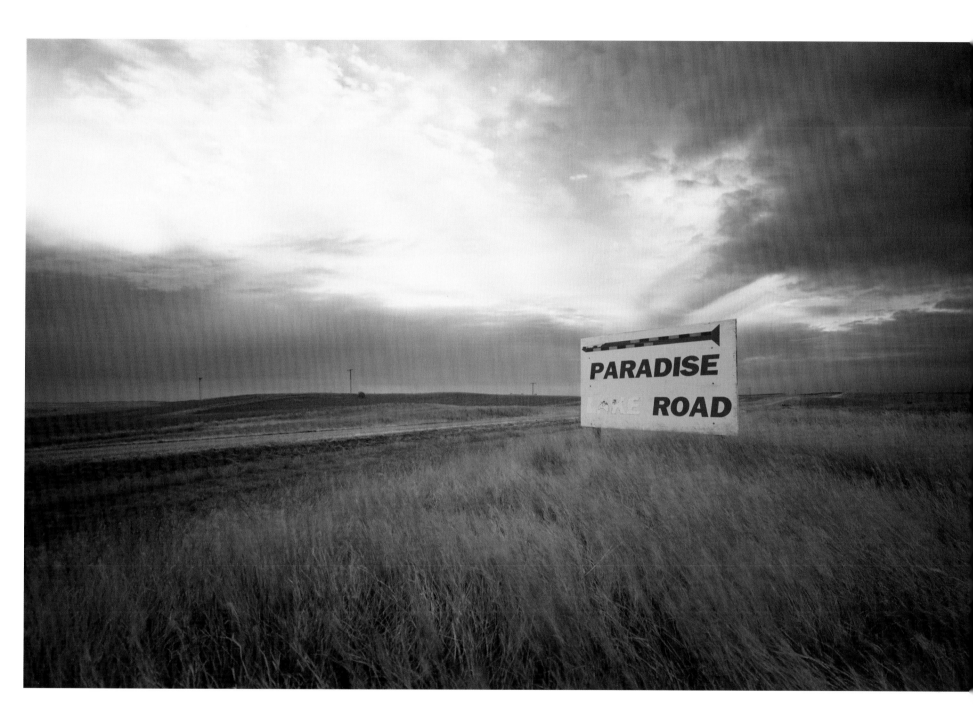

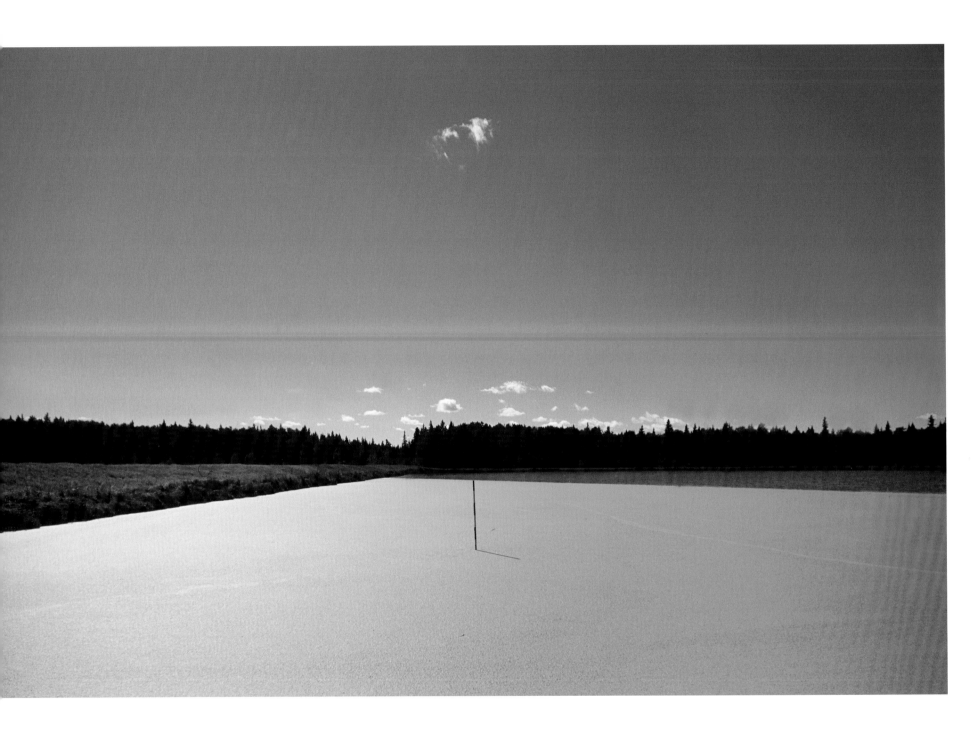

Sewage lagoon, Waskesiu, Prince Albert National Park

*Prince Alberta National Park is at the southern edge of the
northern boreal forest that fills up more than half of
Saskatchewan. Archie Belaney, the Englishman posing as an
Ojibwa named Grey Owl, shared his cabin with beavers
while working as a naturalist in the park in the 1930s. He
wrote books on nature from his isolated cabin and became
famous, then infamous, and he is now famous again.*

On all sides from the cabin where I write extends an
uninterrupted wilderness...here from any eminence a
man may gaze on unnumbered leagues of forests that
will never feed the hungry maw of commerce.
—*Archie Grey Owl* [9]

*Waskesiu, the town site, has been "Saskatchewan's play-
ground" since 1927. The playground swells to more than
5,000 visitors on long weekends in July and August.
One hot summer, I spent many hours watching the duck-
weed (and ducks) move about on the surface of Sewage
Lagoon No. 3.*

Montreal Lake First Nation

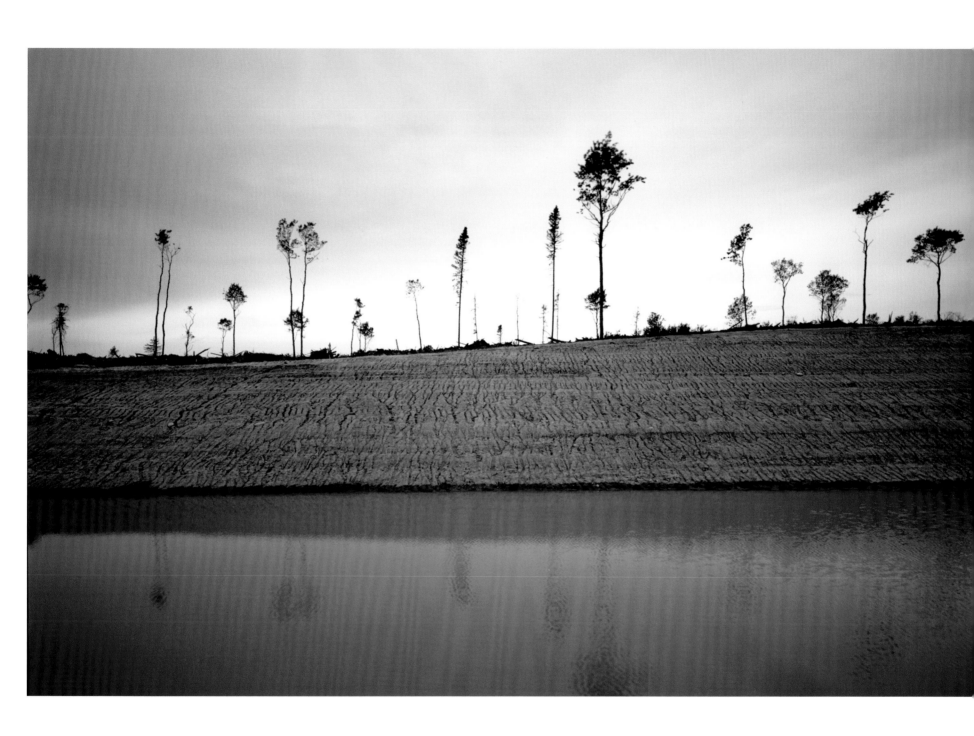

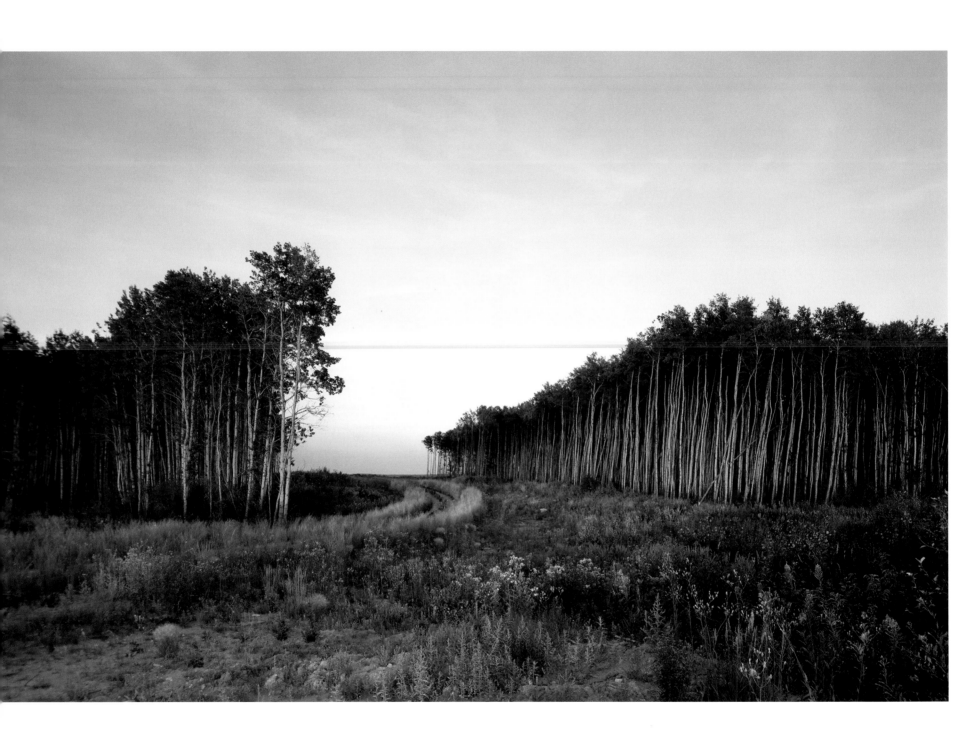

Weyerhaeuser Demonstration Forest, Clarine Lake

At about the latitude of Saskatoon, aspen parklands are seen on the Saskatchewan grasslands, extending north to the boreal forest. Clarine Lake is at the southern edge of the boreal forest where logging begins. Weyerhaeuser, the forestry giant, recently entered into a joint venture with three northern Indian bands.

Rural Municipality of Big Stick

I was never quite sure what to make of Marlon and Wade. They were incontrovertible evidence of the vast and mysterious divide between farm kids and town kids. Even their vocabulary was different. They said crik instead of creek, and dinner instead of lunch, and when a sow had her babies they said "she pigged." They uttered threats about each other's "coils" ("You don't shut the fuck up I'll boot ya square in the coil"), and they asked if I knew how to "drive truck." Both of *them* drove truck, and drove tractor, and sometimes even drove combine. They also knew how to weld, and how to skin a coyote (I was puzzled they didn't say "skin coyote"), and they could grab the electric fence for three seconds at a time without crying.

—*Warren Cariou* [10]

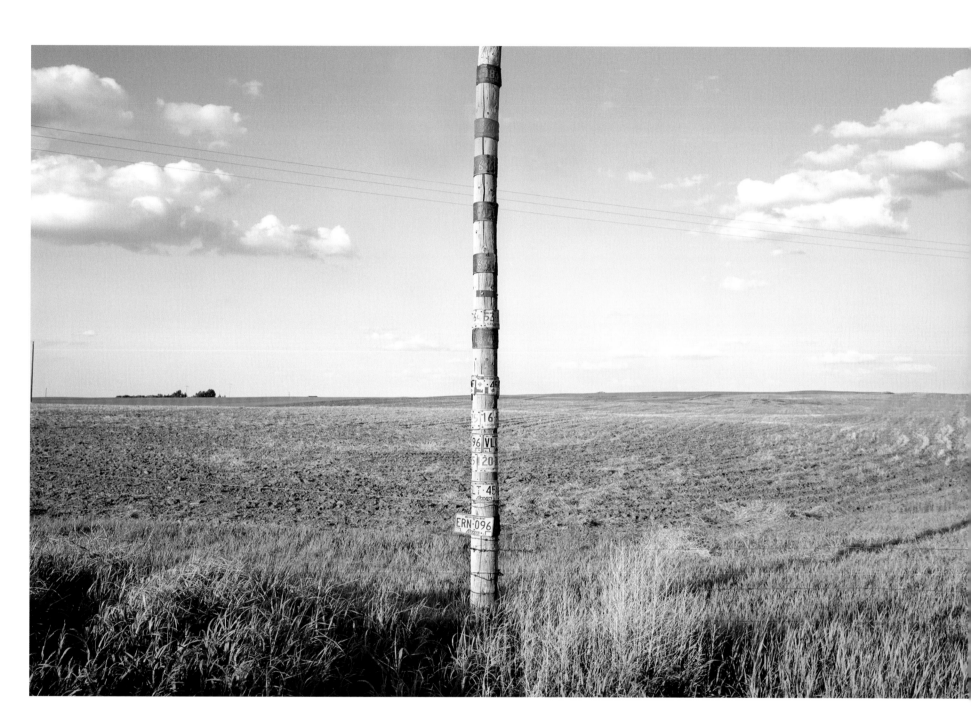

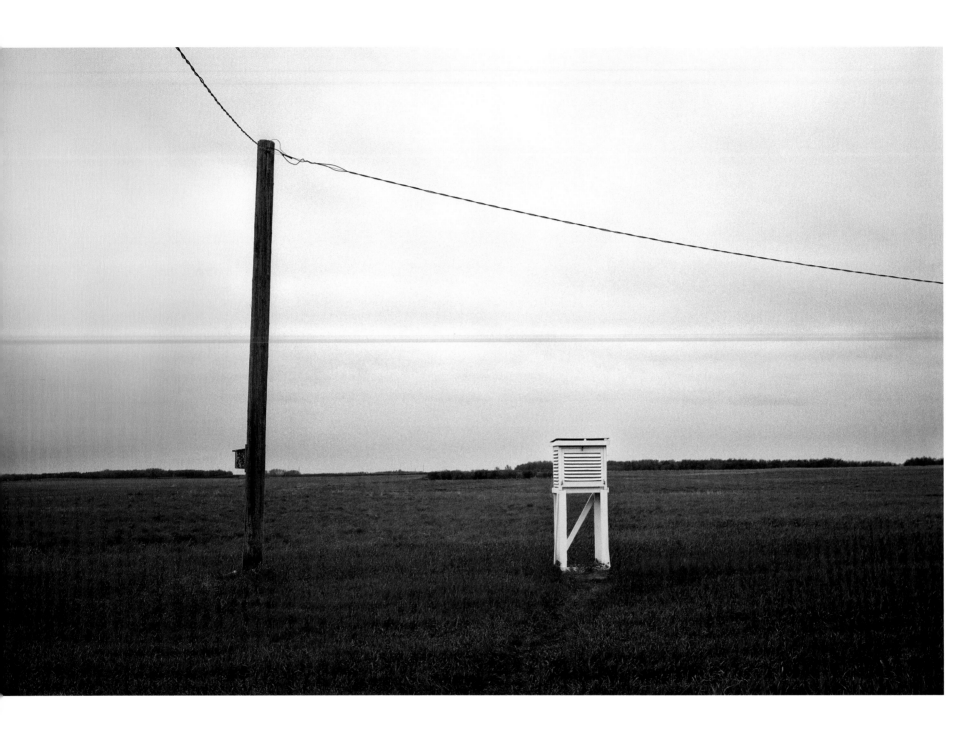

Weather station, St. Peter's monastery, near Muenster

Near Saskatoon

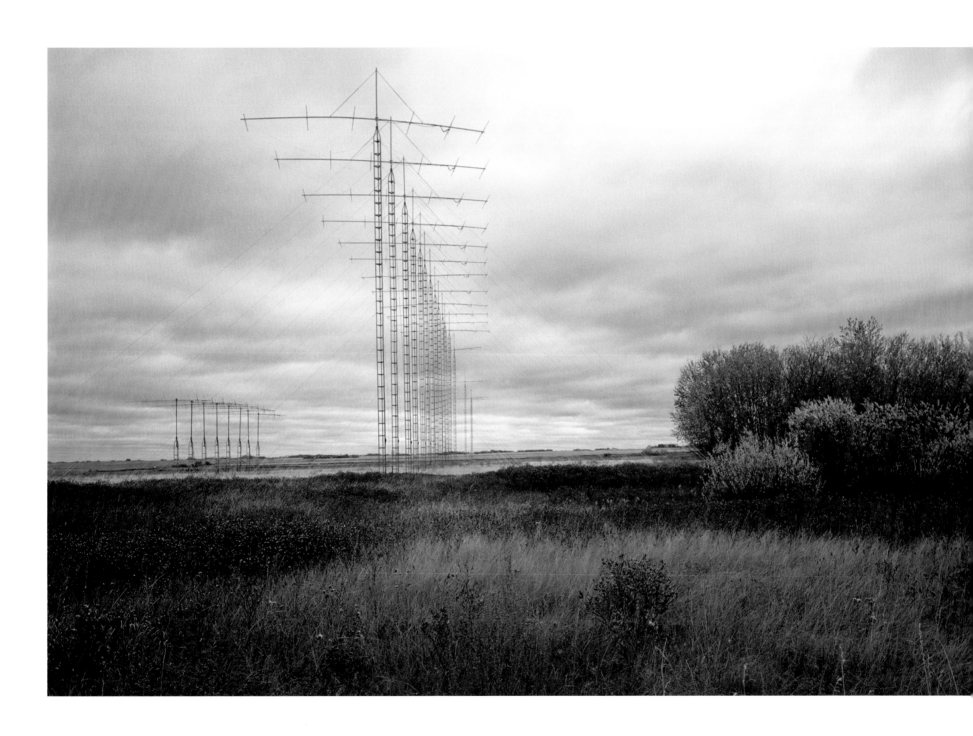

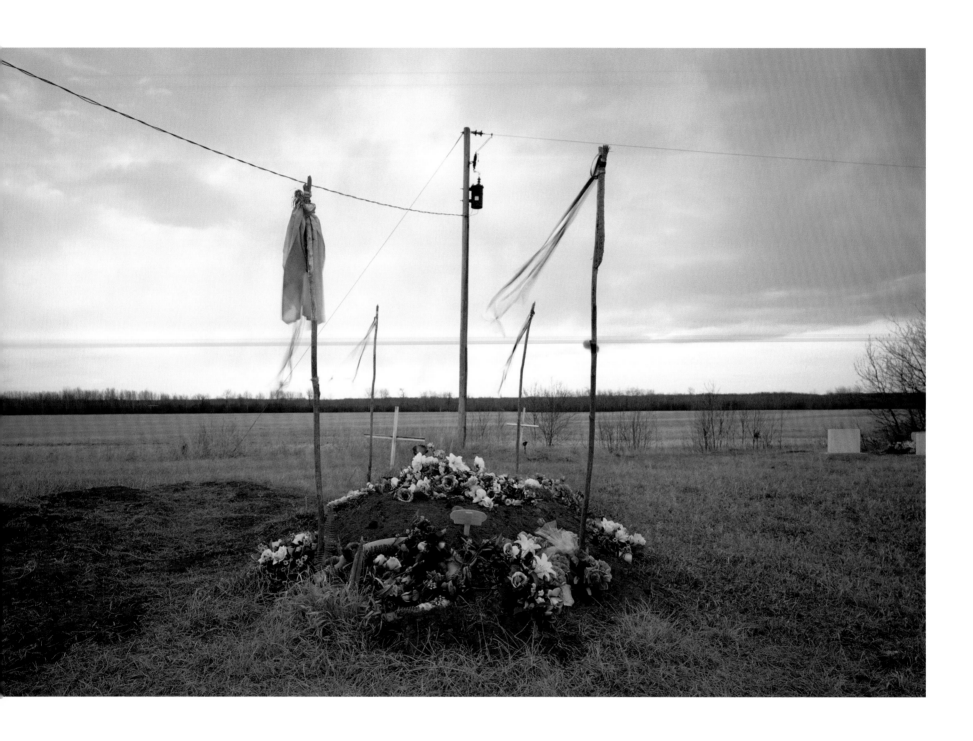

Rural Municipality of Prince Albert

Big River First Nation

In 1895, the Sun Dance was outlawed; Chief Piapot, a signatory of Treaty 4, was jailed for performing a Sun Dance on his reserve near Regina.

In the ceremony, the buffalo was honoured. The buffalo symbolized life for it was the buffalo that provided for food, clothing, shelter, and most all utensils.

I heard a chief say that just as the buffalo meant life to their ancestors, today, it is education, "getting an education," that is the buffalo for his young people.

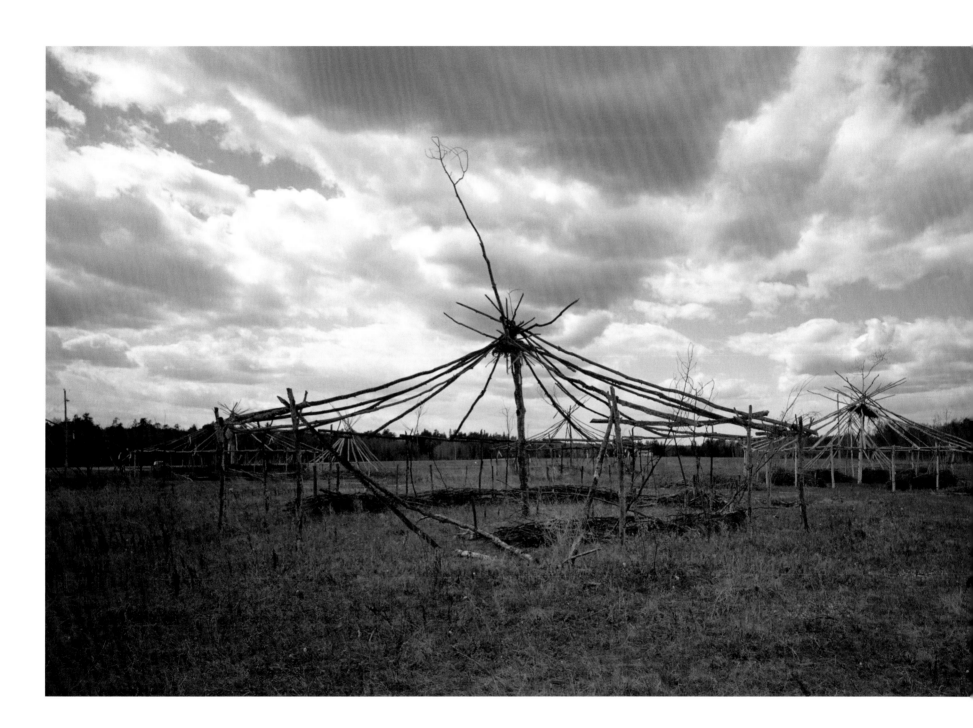

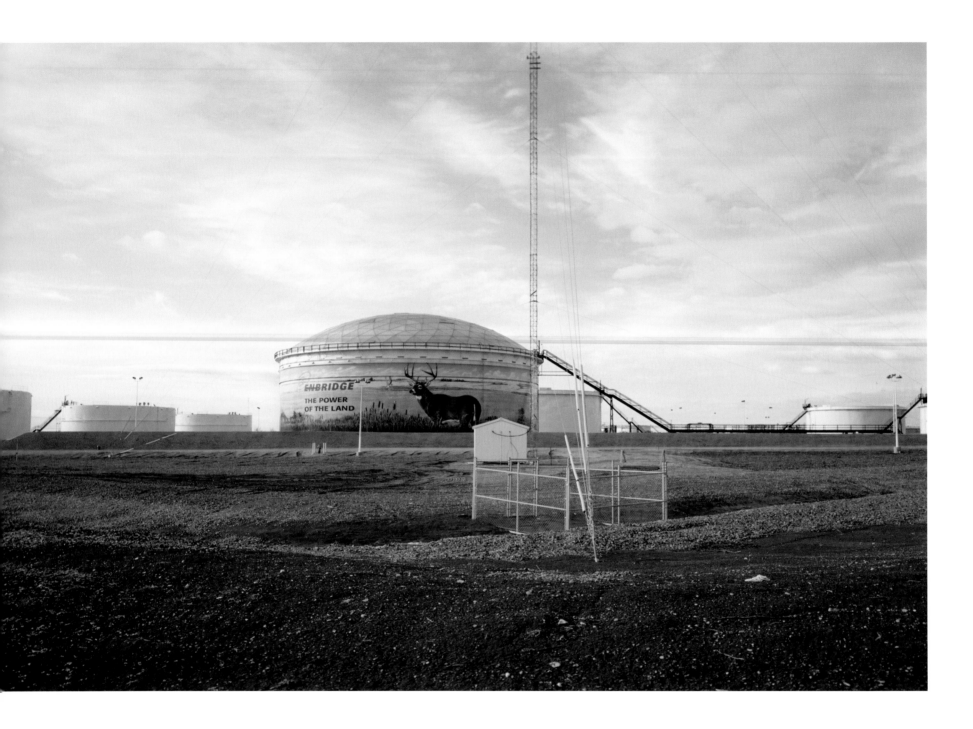

Regina

Mural, Duck Lake

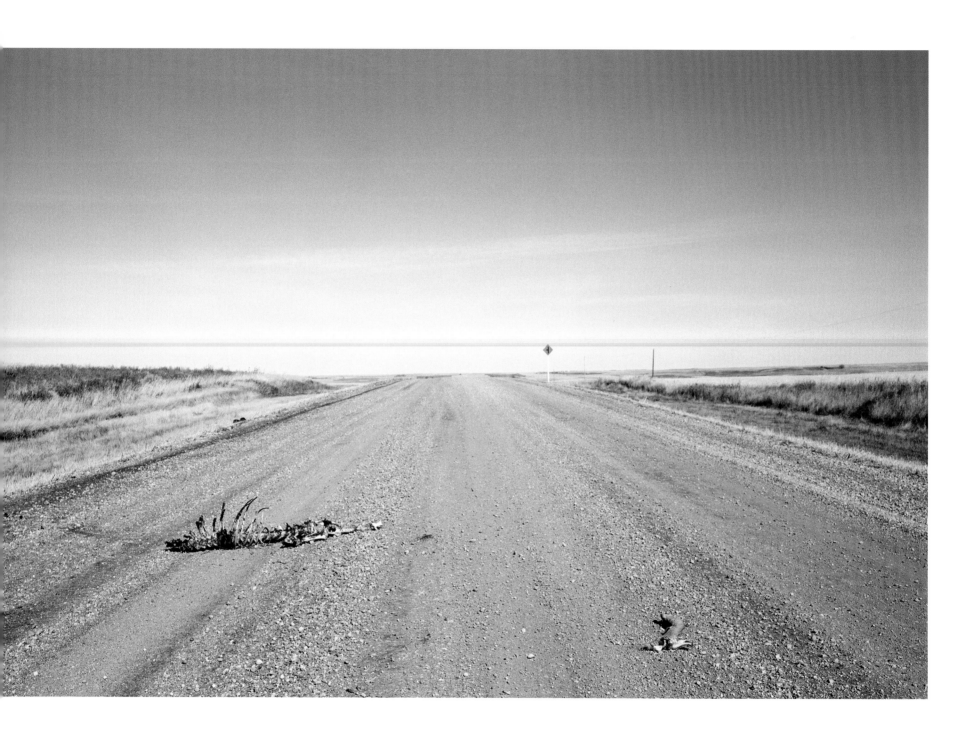

Deer carcass, near Prairie View

When John Palliser first came upon the area around Prairie View in 1859, it was buffalo, not deer that he saw:

> We are now in the heart of buffalo country. This region may be called a buffalo preserve.... The whole region as far as the eye could reach was covered in buffalo bands varying from hundreds to thousands. So vast were the herds that I began to have serious apprehension for my horses, as the grass was eaten to the earth. [11]

White-tail deer are now the most numerous wild ungulate in North America.

Rural Municipality of White Valley, No. 2

More oil and gas come from Saskatchewan than from any
other province, except of course Alberta. More beef comes
from Saskatchewan than from any other province, except
Alberta. More educated young people leave Saskatchewan
than they do from any other province; most go to Alberta.

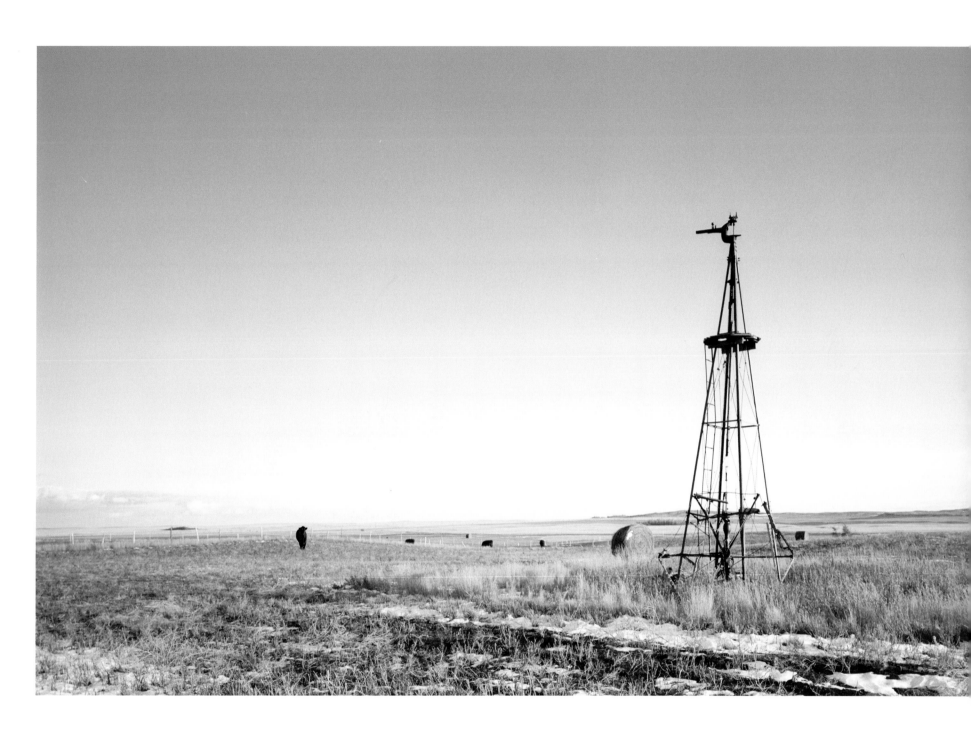

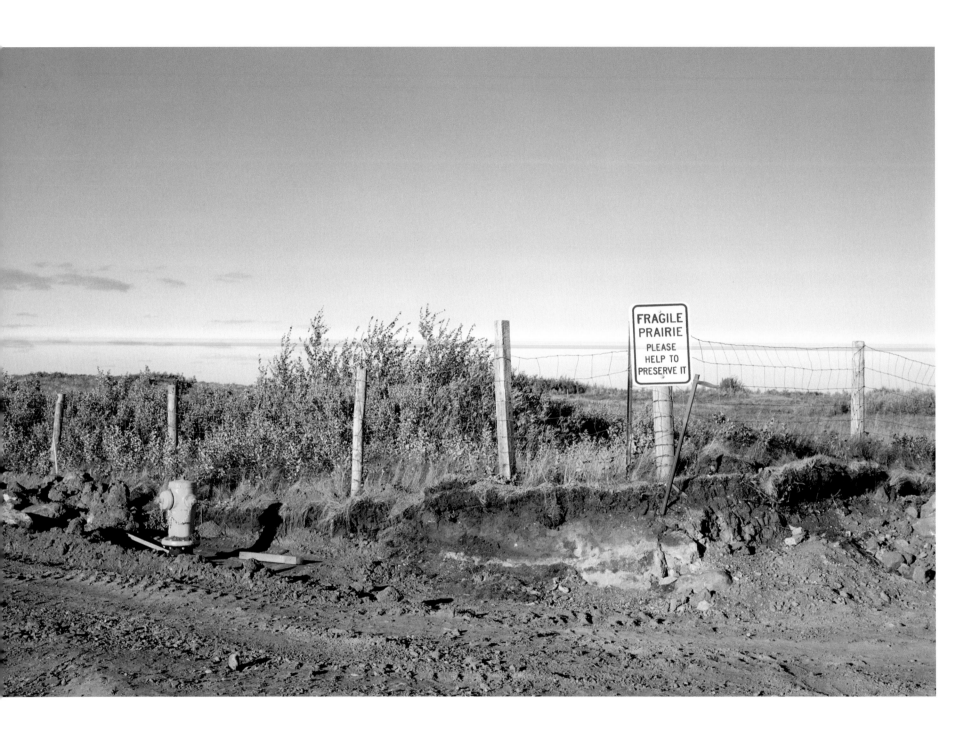

Saskatoon

This bit of natural prairie grassland, not far from my house, is now the site of a sprawling new sub-division on the edge of Saskatoon.

Salt flat, on Pamela Wallin walk, Wadena Wildlife Wetlands

These wetlands, near Pamela Wallin's home town, are sometimes wet and sometimes dry. Named by the United Nations as among the world's Wetlands of International Importance, severe droughts in the past few years have shrivelled these wetlands around the Quill Lakes. A wet-dry cycle, so familiar on the prairies, appears to be necessary for the regeneration of plants in marshes and sloughs.

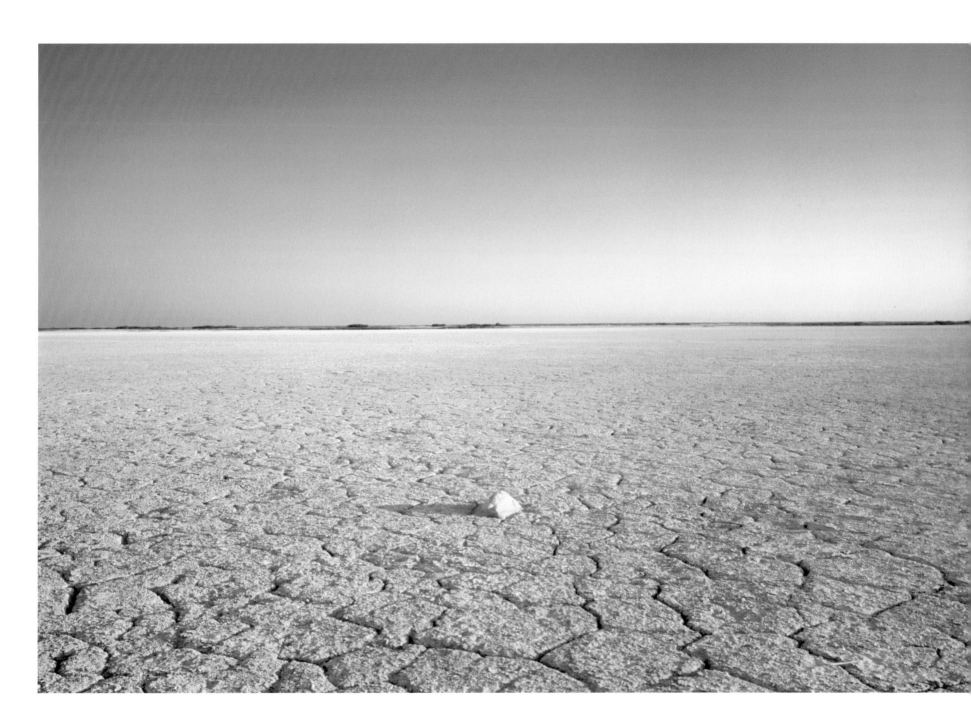

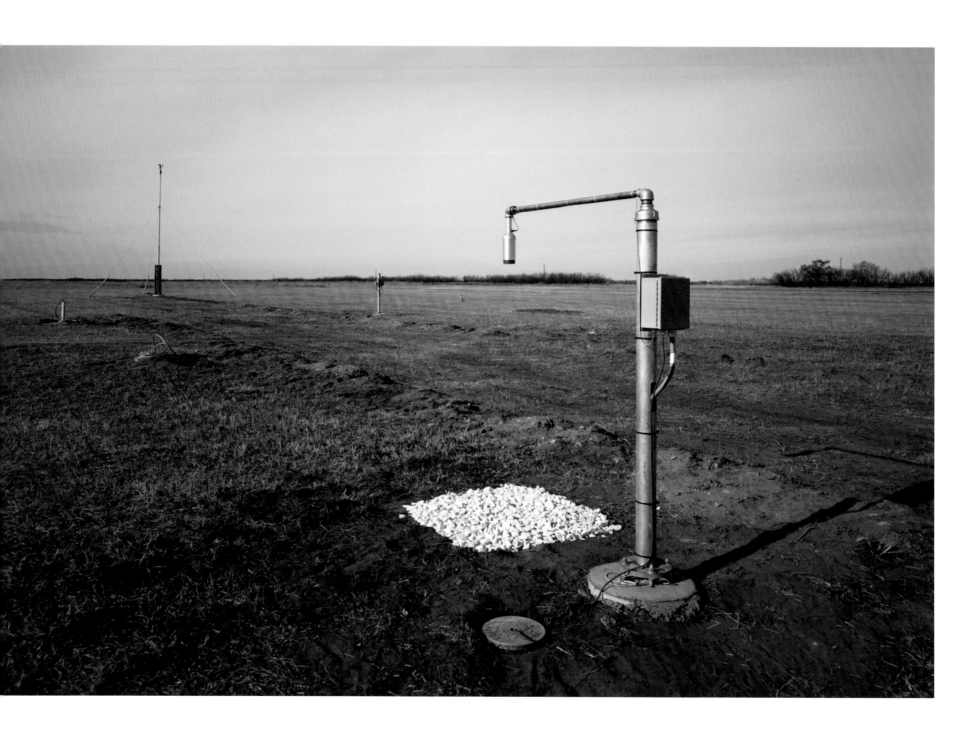

Weather station, Last Mountain Lake National Migratory Bird Sanctuary

Rural Municipality of Wood Creek

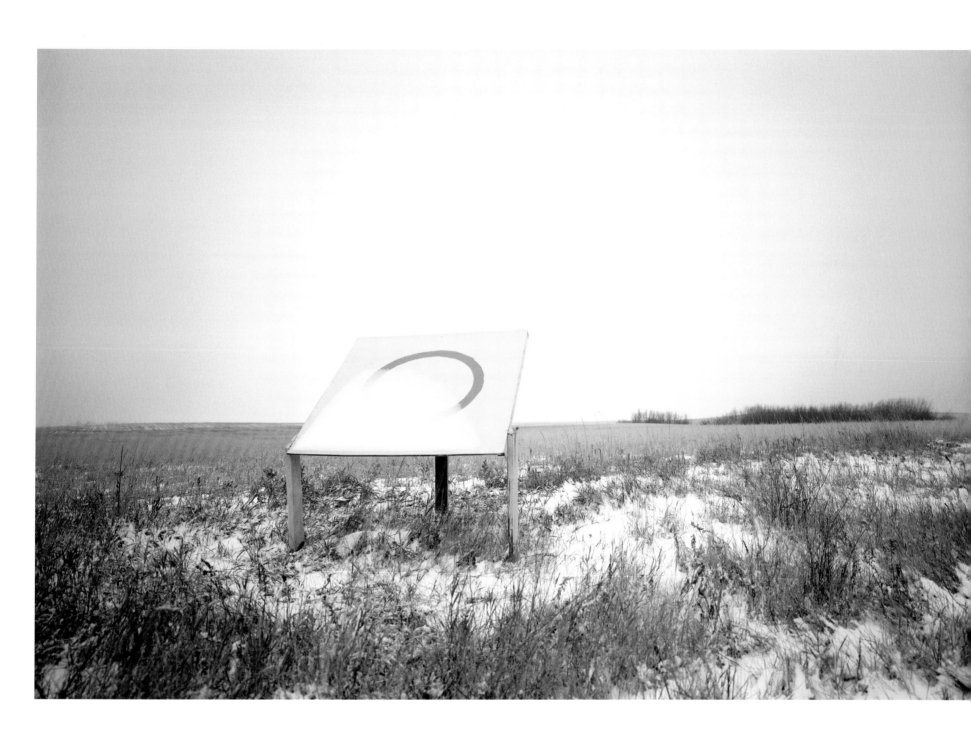

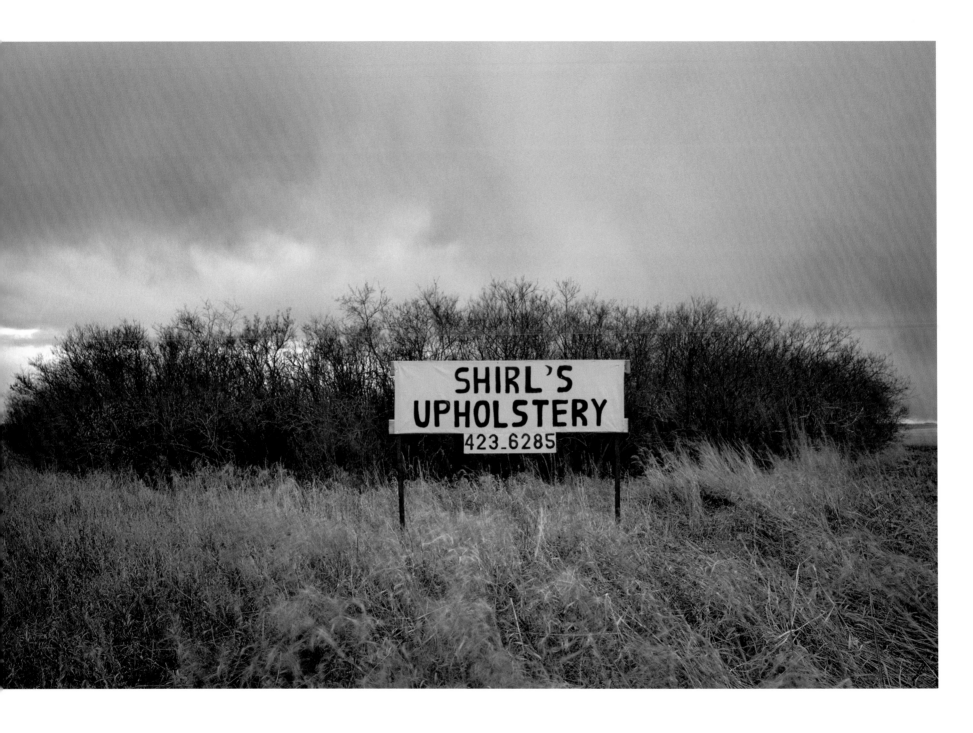

Shirl's Upholstery, Highway 2, near Domremy

Shirl has done upholstery out of a mobile home for twenty-five years.

Highway 11, Louis Riel Trail, Rural Municipality of Duck Lake

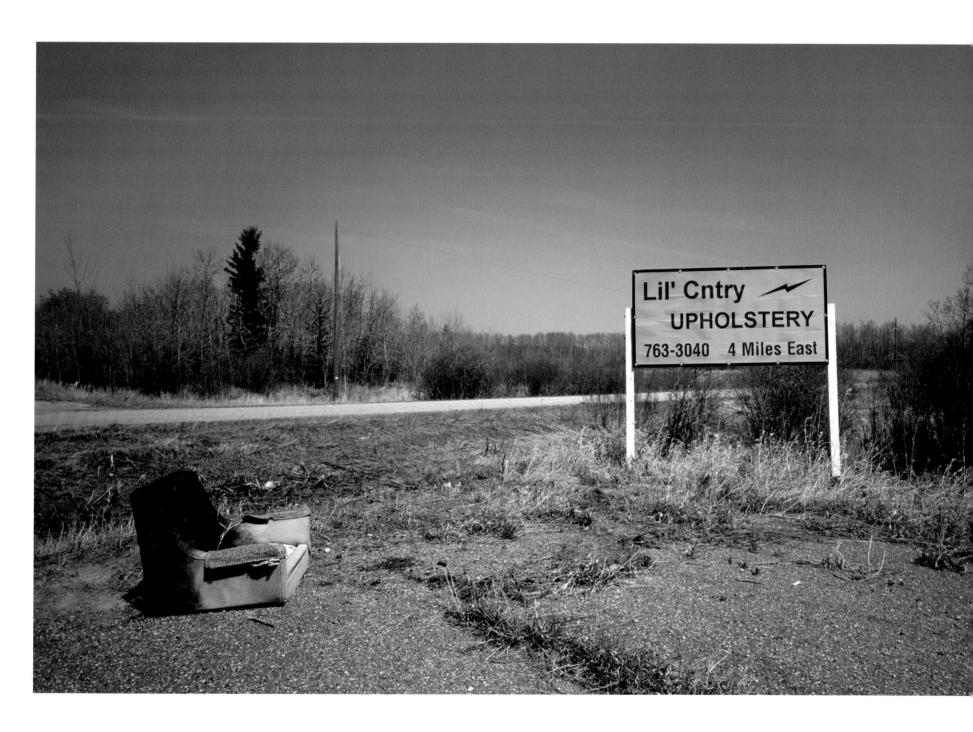

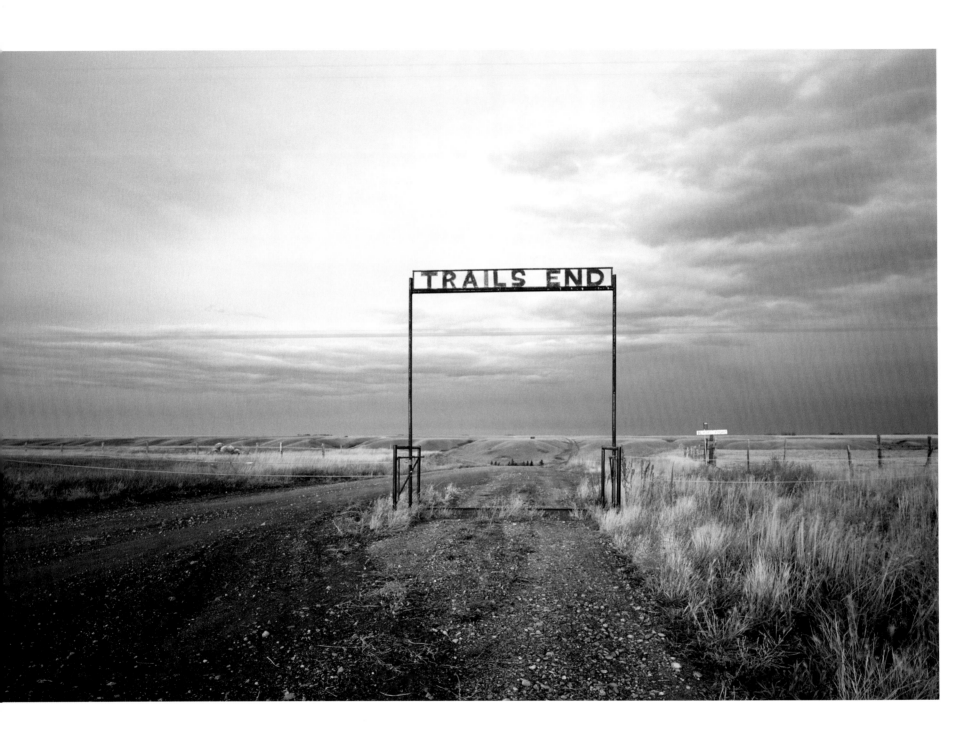

Rural Municipality of Craik

Former Hamlet of Winter, Rural Municipality of Senlac

*This was Winter, Saskatchewan, memorialized by Tim
Lilburn, the poet-philosopher-Saskatchewanean:*

> Geese are back but out of sight, moving on green-
> purple, saline ice,
> the April frog sound of natural gas kicking
> up in the thigh-big water heater in room 15, rig smell
> of the carpet, wool
> sock rig smell of the bath mat, sheets toenail
> sliced dust,
> the moon in the socket of the ear.
> It's better to be forgotten. No one ever gets around to
> saying this.
> Better to live in a place like Winter, Sask., for
> instance, though this is hard to think. [12]

*Lilburn has moved to Victoria, B.C., for a good teaching job.
There he joins Lorna Crozier and Patrick Lane—Saskatchewan
ex-patriots, Governor General's Award-winning poets
all three.*

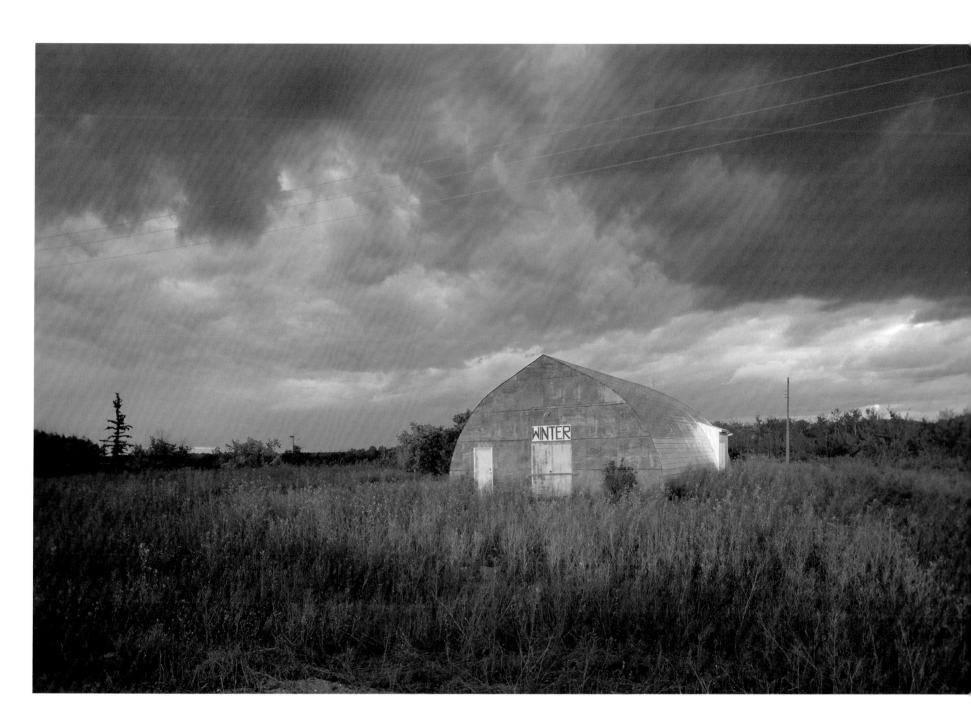

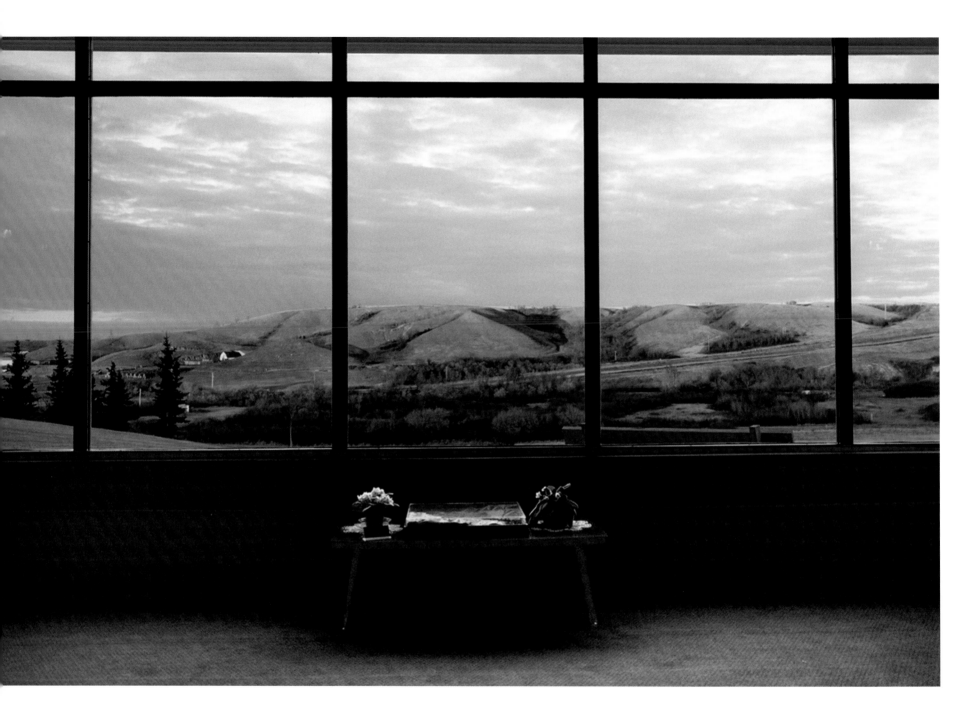

St. Michael's Retreat House, Qu'Appelle Valley, near Lumsden

This is the valley of the river that calls. French settlers in the 1800s began calling the river and the valley Qu'Appelle, a translation of the Cree name, kâ-têpwêwi-sîpiy or the What is Calling River.

The Qu'Appelle Valley has been an important spiritual site, cultural crossroads, and gathering place for untold generations of aboriginal peoples and at least five generations of immigrant Canadians. For most of these, the Qu'Appelle was the vision of an earthly paradise, a respite from the dry and sun burnt open spaces to the north and south, east and west. Its tawny hills and lush green lakeshores stand out in sharp relief against the prevailing flatness of the south-Saskatchewan prairie.

—Dan Ring [13]

First Nation cemetery

In this and every other First Nation cemetery are buried a great many whose culture, life in fact, was taken away from them by colonial practices such as the Indian residential schools that, for more than sixty years, removed children from their families and communities.

"Hello merry, mutter of cod, play for ussinees, now anat tee ower of ower beth, aw, men." Gabriel rattled off the nonsensical syllables as nimbly as he could, pretending he knew what they meant. But, his knees hurting from the cold, hard linoleum, he couldn't help but wonder why the prayer included the Cree word "ussinees." What need did this mutter of cod have of a pebble?

—*Tomson Highway* [14]

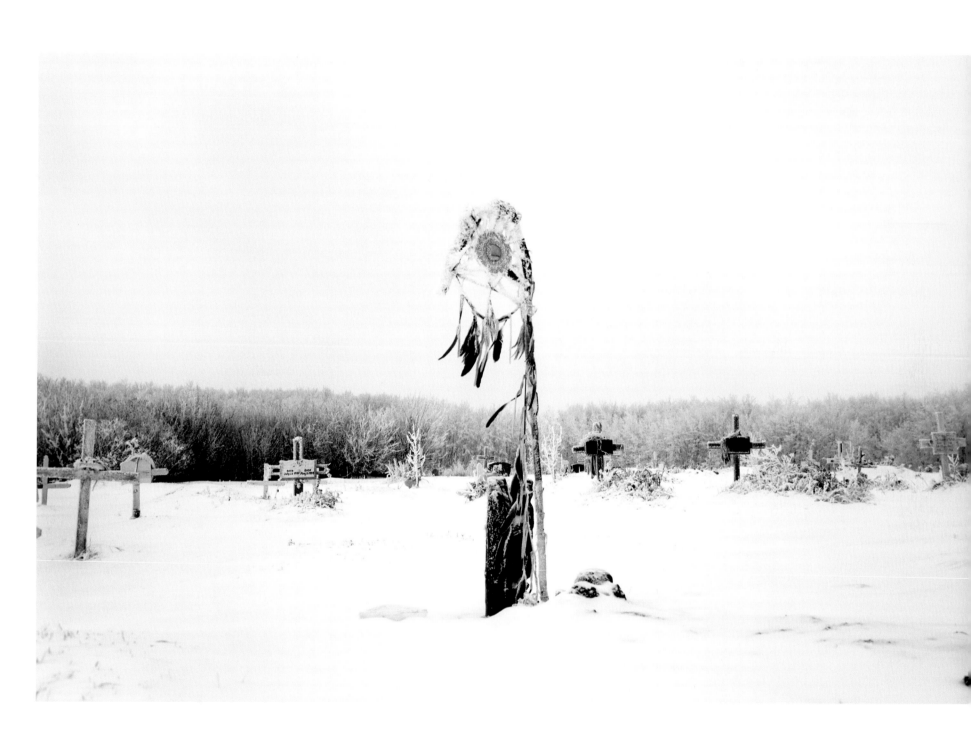

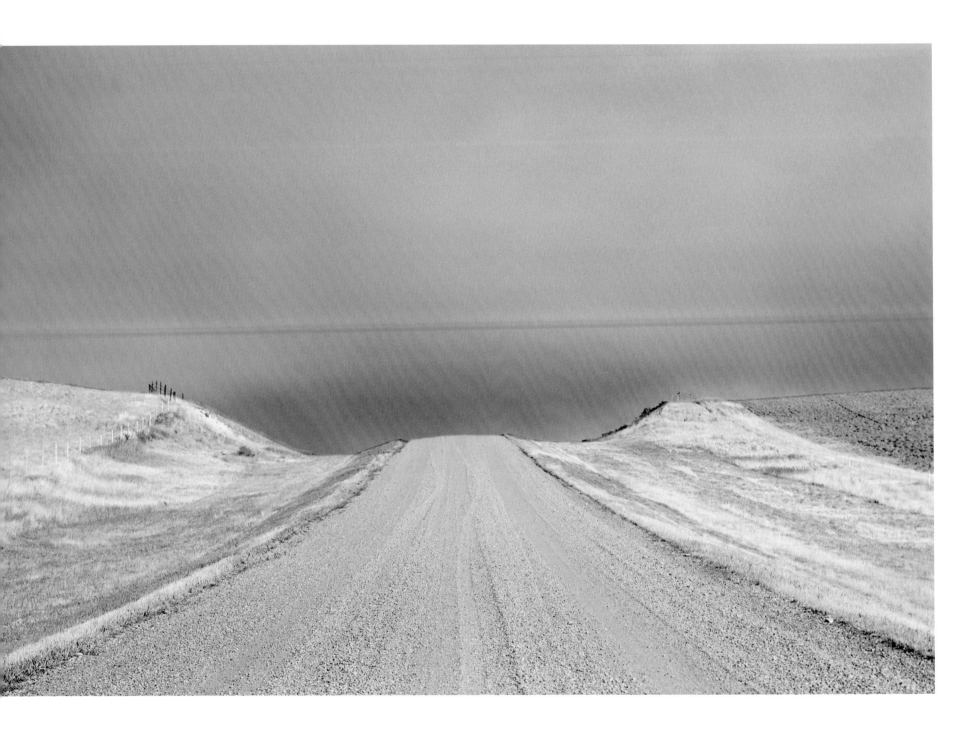

Rural Municipality of Arlington

There it was still, a road pointing off somewheres.
Right enough, it give him a clutch in the throat. It hurt
him with its straightness and its promise.... But he knew
it one better. He knew there weren't no straight roads.

—*Guy Vanderhaeghe* [15]

John Conway

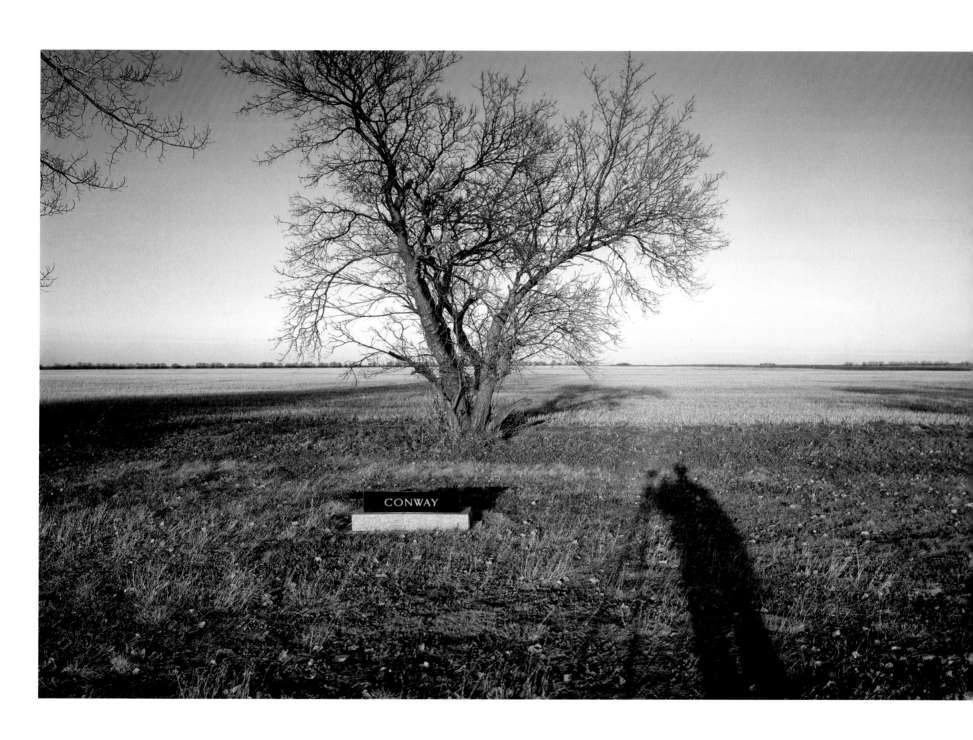

NOTES TO PHOTOGRAPHS

1. Bill Waiser, *Saskatchewan: A New History* (Calgary: Fifth House, 2005).

2. Sharon Butala, *The Perfection of the Morning* (Toronto: HarperCollins Publishers Ltd., 1994).

3. Quoted in Bill Waiser, *Saskatchewan: A New History* (Calgary: Fifth House, 2005).

4. All the numbers are taken from John W. Warnock, *Saskatchewan: The Roots of Discontent and Protest* (Montreal: Black Rose Books, 2004).

5. Penny Cousineau-Levine, *Faking Death: Canadian Art Photography and the Canadian Imagination* (Montreal: McGill-Queen's University Press, 2003).

6. Don Kerr, "Editing the Prairie," in *A Sudden Radiance: Saskatchewan Poetry,* Lorna Crozier and Gary Hyland Eds. (Regina: Coteau Books, 1987). Used by permission of Don Kerr and Coteau Books.

7. Candace Savage, *Prairie: A Natural History* (Vancouver: Greystone Books, 2004).

8. Les Crossman, "Dustbowl Baseball," in *Saskatchewan Baseball Association Digest* (Battleford: Saskatchewan Baseball Association, 1985).

9. Archie Grey Owl, *Tales of an Empty Cabin* (Toronto: Macmillan of Canada, 1936).

10. Warren Cariou, *Lake of the Prairies* (Toronto: Anchor Canada, 2003). Extracted from *Lake of the Prairies* by Warren Cariou. Copyright © Warren Cariou 2002. Reprinted by permission of Doubleday Canada.

11. John Palliser, *British North America: Further Papers Relative to the Exploration by the Expedition Under Captain Palliser of That Portion of British North America Which Lies Between the Northern Branch of the River Saskatchewan and the Frontier of the United States and Between the Red River and the Rocky Mountains and Thence to the Pacific Ocean* (London: G.E. Eyre and W. Spottiswoode for Her Majesty's Stationery Office, 1860).

12. Tim Lilburn, "Sleeping Four Nights in a Tree," in *Kill-site* (Toronto: McClelland & Stewart Ltd., 2003). Used by permission of Tim Lilburn and McClelland & Stewart Ltd., The Canadian Publishers.

13. Dan Ring, *Qu'Appelle: Tales of Two Valleys* (Saskatoon: Mendel Art Gallery, 2002).

14. Tomson Highway, *Kiss of the Fur Queen* (Toronto: Doubleday Canada, 1998).

15. Guy Vanderhaeghe, *The Englishman's Boy* (Toronto: McClelland & Stewart Ltd., 2003, [1996]).

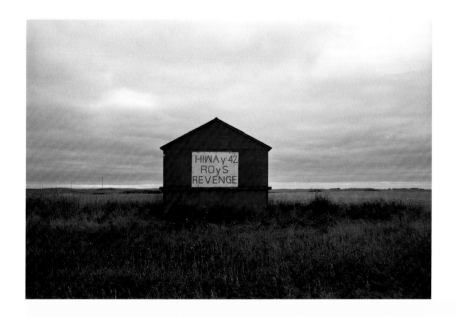

Highway 42, Rural Municipality of Eyebrow

Saskatchewan, Saskatchewan DAVID CARPENTER

MY MOTHER WAS BORN in 1910, the year the family farm went under, somewhere south of Moose Jaw. A few years later, as a small anaemic child in Saskatoon, she had polio. On doctor's orders, her father, Artie Parkin, tethered a Jersey cow in their back yard so that she and her siblings could drink rich milk.

The money for the cow, the rent money for their house, sometimes their very subsistence, came largely from my grandmother's father in Toronto, a charming hardbitten Irish patriarch who disapproved of his daughter's husband. Artie Parkin may well have been an indifferent husband and father, but he was great with motors, guns, metal work and carpentry. He was a man's man, a poet, an inventor, and a legendary angler, and he was cursed when it came to money. If a prospector came to his door with a tale of gold somewhere near La Ronge, Artie opened his heart and his wallet. My grandfather's name must have been on a list for impecunious prospectors all over the north. Artie went from farming to grubstaking prospectors to

127

investing in Chinese mink to raising prize hens in his garage to brokering insurance and real estate and back to grubstaking prospectors and other dreams of quick cash.

My mother and her beautiful sister and their younger brother grew up in Saskatoon. They lived in a two-storey frame house with a big welcoming front porch where all the ardent boys in the neighbourhood would come to sport with my mother and her sister, who had both become flappers, dancers, great singers. The house had a parlour that was filled with stuffed game birds and the pelts and heads of large animals. Granny Parkin referred to this parlour as the morgue. They had a converted carriage house in the back where an arkful of animals were raised with the hope of easy money, and slaughtered for other, sadder reasons.

My father was born in 1905 on a railway siding in a dead town somewhere near Peterborough. When he was a few weeks old, much to the chagrin of his mother, my dad's family moved to Saskatchewan. My Grandmother Carpenter took one look at the muddy streets of Regina and fired off a plaintiff note to her people in Peterborough: *Like I've always said, the East for me!*

My father spent a mischievous youth along Wascana Creek, trying the patience of neighbours with his two brothers. The Dirty Carpenters, they were called. My Grandfather Carpenter was a land surveyor from Collingwood. On all the survey maps and legal subdivisions from the earliest years of this province, my grandfather's signature can be found. Like my other grandfather, Artie Parkin, he somehow believed in Saskatchewan. He told his three boys and their two sisters that some day soon, Saskatchewan would have a million people. Just imagine, in a few years, one million people. This was a province of the future, a place to stake your claim. Regina was not just a little town built on a pile of buffalo bones; it was going to be another Chicago. Towards the end of his career, my Grandfather Carpenter was honoured by the Government of Canada for his work as a surveyor and later as a civil servant. They named a small Ukrainian settlement after him, somewhere south of Wakaw. Carpenter shrank from a village with a railway and a grain elevator to a hamlet with neither, to a ghost town. By the mid '60s, the name of Carpenter was removed from the highway maps.

My mother's family has disappeared. The last of the Saskatchewan Parkins moved to Vancouver ten years ago. My father's family has also disappeared from this province, returned to Ontario where my Grandmother Carpenter always wanted to be in the first place. The province of Saskatchewan is still just on the verge of one million people. During a recent three year drought where I live, in Saskatoon, you could venture out in any direction from town and see the prairie dry up and blow away. It looked like the end of the world. It looked like the end of Artie Parkin's prophesies for a sportsman's paradise, the end of Grandfather Carpenter's prophesies for a Promised Land. It looked like one of those dried-out golf courses you might view in a photo by John Conway (page 70).

In Regina and Moose Jaw and up in Prince Albert, and especially in the small towns of Southern Saskatchewan, we compared our status as drought communities. We all claimed to have the hottest temperatures, the most farm foreclosures, the flattest economy, the most indifferent responses from our federal politicians, the thickest dust storms, the most grasshoppers per acre, and before long we were bragging about it. And here is a key to the Saskatchewan identity: after our recovery from the dustbowl of the

Thirties, after uranium discoveries, oilfield windfalls and potash revenues, we still derive our sense of who we are, collectively, from our stories of desolation and bare-minimum survival. Just about bought the farm. Just about totaled 'er. Nearly didn't make it. Got our seed back, that's about all. Haven't hosted a playoff game for damn near half a lifetime. We are not first family snobs or horsey snobs or big money snobs or artsyfartsy urban snobs—we are survival snobs.

My mother and father met and courted in Saskatoon, married, and lit out for Alberta. My dad got a job as a salesman in Edmonton and my mother gave birth to two healthy boys. Around the time my brother and I were starting school, the Great Depression was over, World War II was over, and there was a big oil strike near Leduc, which guaranteed William Aberhart's Social Credit party a success of biblical proportions. Several times as kids we were taken back to Saskatoon and Regina to visit our grandparents, and I never failed to be impressed each time we crossed the border into Saskatchewan. On the road map, it looked like a perfectly straight line. The people looked the same on both sides of Lloydminster, talked the same, but something on the eastern side of that border felt different, as though we had crossed an international checkpoint into a storied land. A storied land with real boring scenery.

On an Alberta holiday, if you managed to weather the carsickness, the fights with your brother in the back seat, the admonitions from your exasperated parents in the front seat, you got to see the mountains. On a trip to Saskatchewan, you got to see Granny Parkin in Saskatoon and Granny Carpenter in Regina. A storied land with real boring scenery.

I was not aware that while the Social Credit Party in Alberta was floating on an evangelical dream of God-given oil and prosperity, Tommy Douglas and members of the Co-operative Commonwealth Federation (CCF) Party were talking about universal medical care, mandatory two week holidays for workers, and bringing electricity and plumbing to rural Saskatchewan. And all this happened on opposite sides of the border at the very same time.

Saskatchewan was a storied land, because throughout my youth, I grew up on Dad's stories: goose hunting stories, stories of how people made do during the Great Depression, stories of dust storms and blizzards unrelieved by what Albertans call chinooks, stories of crop failures and hockey games and dancing on the roof of the King George Hotel; or the day Granny Parkin's dog chased away a tramp who had forced his way into her house. The church basement where Dad went to communist meetings during a stretch of unemployment. Mum and Dad's honeymoon trip to Lake Waskesiu, fore-shortened when a bear tore their tent to shreds.

This is a shameful admission, but I was born in a safe, safe place. Life in Edmonton, for the Carpenter family, meandered along in a series of prosaic successes. In Edmonton, when pot-holes appeared on the streets, *the city came and fixed them*. Alberta's highways unfurled throughout the province as smooth and pristine as patent leather. When pot-holes appeared on the highways, *the provincial highway crews came and fixed them*. When traffic increased between Edmonton and Calgary, they doubled and divided the highway. Brother Pete and I went to a nice school and we did okay. We got to live in a neighbourhood full of kids. On special occasions we got to eat supper in the cafeteria at the MacDonald Hotel, which to me looked like a castle. Like many a business in Edmonton, the MacDonald Hotel got so popular that they had to build an annex. The new annex was built in the shape of a rectangle. It was so big it dwarfed the old Macdonald. We called it the

Macdonald Hotel and the box it came in. Somehow, that was Edmonton.

By the time the Sixties rolled around, we owned our own house. Dad got to be a manager. Our football team was almost unbeatable. Our neighbours bet each other on the games. Mum usually took Saskatchewan. She usually lost. Pete and I went to university. We graduated and got jobs. (There might be a story in all this, but I haven't found it yet.)

Through a series of misadventures, wrong decisions, depressions, heartaches, humiliations, and owing to the determination of an old badger, I landed a job as an English professor at the University of Saskatchewan. I got an apartment at the edge of Saskatoon's downtown area a few blocks from where my mother grew up and about one hundred metres from where I was conceived. I would walk downtown at nights and find no one there. I discovered that wherever I walked in the presence of people, I moved much faster than they did. When I took the bus to various locations throughout the city, the drivers actually spoke with me. They often arrived behind schedule and when I glared pointedly at my watch, these drivers seemed to be saying, "*What's your hurry, pal?*" Alberta has always had a boom and bust economy tied to the price of oil and the expectations of eager capitalists. Alberta has just about cornered the northern market on optimism. Saskatchewan has usually had a much flatter economy tied to the deepseated conviction that tomorrow will bring more of the same. More wind, low commodity prices, and if we're lucky, maybe enough rain to keep the dust down. In Saskatchewan, optimism is a guarded hope.

I love this place, but explaining this love to outsiders is not easy. Let me try. During a long stretch of creative angst, I re-visited my hometown, where the novel I was trying to write was set. Edmonton had gone from scarcely more than 250,000 people to well over half a million. The Gretzky era was in full swing and the great comedy revue, SCTV, was being filmed there. I couldn't find the house we rented when Pete and I were born. It had been torn down, I discovered, along with several neighbouring houses, and a beautiful townhouse complex had emerged in its place. I had trouble finding the other one as well, the one my brother and I grew up in, because it had been so brutally gentrified, it was a different house in what seemed to me a different neighbourhood.

My house in Saskatoon was built in 1912, a two and a half storey frame house in a neighbourhood blessed with many old elms, many writers and artists, and a three minute walk to the river valley. I can walk over the Broadway Bridge and in fifteen minutes I can be standing in front of my mother's old house. Like my house, it hasn't changed one bit in almost a century. I can drive to Regina and visit the house where my dad grew up. I compare it to the photos from 1925 and, yes, it's the same house. Every summer I drive down to Moose Jaw for the Festival of Words to become a literary tourist. The downtown core is pretty much unchanged from the roaring twenties.

This old core and these houses haven't been torn down and/or tarted up because few people in Saskatchewan can afford such atrocities. We are just as stupid as other provinces in our willingness to destroy buildings that evoke our past history, but there is not quite enough stupid money to go around. So, in relative terms, more of our neighbourhoods retain their original flavour. In the preservation of these old houses and their neighbourhoods, there is a kind of love that seems, at least on the surface, close to resignation. I've learned to accommodate myself to this kind of love. As I write this, the Saskatchewan Roughriders are about to

play the Edmonton Eskimos for the right to go to the western final. The Edmonton team is nine and nine, and Edmontonians are wondering where they went wrong. The Saskatchewan team is also nine and nine, and we are all excited as hell.

When I drive through John Conway's landscape and see a sign that reads, "Highway 42, Roy's Revenge" (page 61) I assume the maker of this sign is referring to longtime Premier Roy Romanow. What the signmaker is protesting is that this highway is disconcertingly Saskatchewanian in its poor state of repair.

In another stretch of prairie there is a bright blue and yellow sign planted in front of a wild stand of aspens: "Future Home of...Something" (page 2). Along a desolate road rendered impassible by blowing snow on the flattest prairie in the world is a sign with a golfer in plus-fours teeing off. It reads "Imperial Golf Course"

(page 69). There is a series of banners, strung flapping over this road in the frigid wind. Each banner has a letter. Together they read, "Green Fees, $4". Behind a sign, "Shirl's Upholstery," (page 110) lies a leafless tangle of hawthorn bushes and about one million hectares of crop land and pasture.

I like to think of these road signs, in all their tattered glory, their very insistence on the absurdity, yet the primacy of rural life, as the true mottos and heraldry of this province. Along with the experimental canola plants near Rosthern, draped in plastic covers and massing like the ghosts of griping farmers past, these images speak eloquently to me of the hopes of people like my grandparents, hopes dashed and tattered and rising once again, upbeat and sassy, all over the beat up land.

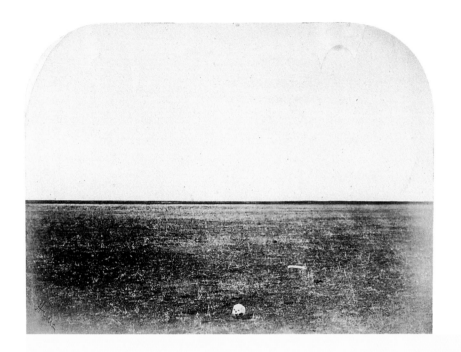

Uncommon Views JOHN CONWAY

Humphrey Lloyd Hime, The Prairie looking west, *September-October, 1858,*

National Archives of Canada (C017443)

ABORIGINAL PEOPLES called the place "Kisiskatchewan," the waters that flow rapidly, the Saskatchewan River. W.F. Butler experienced it as "The Great Lone Land" when he travelled through The Saskatchewan Country in 1872.[1] Dennis Gruending titled his book of selected writing from Saskatchewan "The Middle of Nowhere."[2] And, broadcasting his last morning radio show, from Moose Jaw, Peter Gzowski referred to it as the most Canadian of provinces.

The earliest photographs of Saskatchewan were probably taken by Humphrey Lloyd Hime in 1858.[3] Hime, a surveyor and photographer with the Assiniboine and Saskatchewan Exploring Expedition led by Henry Youle Hind, made a small number of collodion plate images.[4] Only a few of his photographs of Saskatchewan, taken in the Qu'Appelle Valley, have survived.

When I first saw Hime's photograph, "The Prairie looking west," taken near the Red River Colony in Manitoba, I could not get the image out of my head; I still can't. It's not the skull that grips me, it's the prairie.

The land has changed since settlers came. The people who have come here have been changed by it. In my photographs, I show something of the minimal beauty that remains a part of the prairie landscape juxtaposed with tokens of the culture of people who live here. There are paradoxes. And there are funny-looking things, things that have invited me to take a closer look at the land and to wonder about the relationships between this beautiful, tired, ready-to-blow-away land and we humans who live on it.

While photographing Saskatchewan land, my thoughts often turn to the people behind the image—people who have farmed a dry land in a harsh climate, created canola and other crops, built more kilometres of roads and more golf courses per capita than just about anywhere, drilled for oil, mined potash and uranium; and people on the grid roads who wave as they pass by in their half-tons, people like Shirl who has run her upholstery shop out of a mobile home in small town Saskatchewan for twenty-four years.

> Were you and I to drive the plains together, and the day turned out to be a good one, we might not say much. We might get out of the truck at a crossroads, stretch, walk a little ways, and then walk back. Maybe the lark would sing. Maybe we would stand for a while, all views to the horizon, all roads inter-esting. We might find there a balance of form and openness, even of community and freedom. It would be the world as we had hoped, and we would recognize it together.
>
> —*Robert Adams* [5]

A Note on Technique

For most photographs I used 6x7 centimetre colour negative film and a medium format range finder camera. For the book, and for prints, I scanned the negatives using a film scanner, and then made adjustments in Photoshop.

NOTES

1. W.F Butler, *The Great Lone Land: A Narrative of Travel and Adventure in the North-West of America* (London: Sampson Low, Marston & Company, 1891).
2. Dennis Gruending, *The Middle of Nowhere: Rediscovering Saskatchewan* (Calgary: Fifth House Publishers, 1996).
3. R.J. Huyda, *Camera in the Interior: 1858. H.L. Hime, Photographer* (Toronto: The Coach House Press, 1975).
4. H.Y Hind, *Narrative of the Canadian Red River Exploring Expedition of 1857 and of the Assiniboine and Saskatchewan Exploring Expedition of 1858* (Edmonton: M.G. Hurtig, Ltd., 1971).
5. Robert Adams, "Two Landscapes," in *Why People Photograph* (New York: Aperture, 1994).

About the Photographer

JOHN CONWAY has lived in Saskatoon since 1973, where he taught psychology at the University of Saskatchewan, retiring in 2001. He now divides his time between consulting on social policy issues and photography.

He has photographed the Saskatchewan prairie for many years, and recently began to exhibit his work. Photographs from *Saskatchewan: Uncommon Views* have been exhibited at Paved Art + New Media in Saskatoon, Drabinsky Gallery in Toronto, and Image 54 in Calgary.

In 2004, he was awarded first place in Fine Art Landscape Photographs, and Architecture Photographer of the Year, for two series of his photographs of Saskatchewan at the International Photography Awards in New York. Two of these photographs were exhibited at the Farmani Gallery of Contemporary Photography in Los Angeles in 2005.

John Conway was the recipient of an Individual Assistance grant from the Saskatchewan Arts Board in 2005 to extend his work on photographing Saskatchewan. His prints are in the collection of the Saskatchewan Arts Board, and have been purchased by a number of private collectors. His work may be seen at www.johnconwayphotographs.com.